THE WOMEN WHO CHANGED PHOTOGRAPH

First published in Great Britain in 2024 by Laurence King, an imprint of The Orion Publishing Group Ltd, Carmelite House, 50 Victoria Embankment, London EC4Y 0DZ

An Hachette UK Company

10 9 8 7 6 5 4 3 2 1

ISBN (Paperback) 978 1 39961 727 7
ISBN (eBook) 978 1 39961 999 8

Commissioning Editor: Laura Paton
Picture Research: Emily Taylor
Design: Studio Katie Kerr
Senior Production Controller: Sarah Cook

Front cover: *Walls of Silence*, Aïda Muluneh, 2022

Back cover: *Rebellious Silence*, Shirin Neshat, 1994

Origination by f1 Colour
Printed in China by C&C Offset Printing, Co. Ltd

www.laurenceking.com
www.orionbooks.co.uk

And How to Master
Their Techniques

THE WOMEN WHO CHANGED PHOTOGRAPHY

Gemma Padley

Laurence King

CONTENTS

INTRODUCTION

Women have been involved in photography since the earliest days of the medium. Although most photographers – and certainly most professional photographers – were men until about 1890, when easy-to-use cameras became available thanks to Kodak [1], women made photographs too. The most famous are Julia Margaret Cameron (p. 108) and Clementina Hawarden (p. 172), who each contributed in significant ways to the development of the medium.

Women were also engaged in other areas of the photography industry. They helped to run or ran their own studios and were retouchers and tinters. Towards the end of the 19th century, women, although still few in number, worked professionally and sometimes very successfully – as Frances Benjamin Johnston (p. 136), Catharine Weed Barnes Ward (p. 76) and Jessie Tarbox Beals (p. 64) did. As the 20th century got underway and the new independent, self-representing modern woman emerged, women increasingly turned professional. Whereas before female photographers had been operating in the (mostly bourgeois) domestic sphere, they were now working as portrait photographers, press photographers, architectural photographers or working in the advertising industry. They were earning their own money and making their own decisions about the way they wanted to live their life. Indeed, the increased freedoms women were enjoying in photography coincided with, and were sometimes linked to, improvements in women's rights more generally.

Women became more vocal about the need for gender equality in photography. A leading voice was Imogen Cunningham (p. 12) who put the case for why women should take up photography professionally in her 1913 manifesto, Photography as a Profession for Women. And it wasn't only in Western countries that women were creating waves. In Palestine, Karimeh Abbud (p. 160), often referred to as the first Arab woman photographer, was running several photography studios. A formidable businesswoman, she went out of her way to promote herself and her services under the banner of 'Lady Photographer', having shrewdly recognized, and acted on, a preference by some women to be photographed by another woman.

As the decades hurried on, women photographers continued to challenge convention across the board. In photojournalism, Lee Miller (p. 116) pushed boundaries when she entered Germany as World War Two was ending – one of the first photographers to do so – capturing and showing to the world the horrors that had unfolded there. And Florence Henri (p. 56) was a successful, talented photographer whose work defined an era. Latterly, important practitioners have included Shirin Neshat (p. 144), who has made work about the female experience in Iran, Lorna Simpson (p. 196), who challenges notions of race and gender, and Aïda Muluneh (p. 36), who advocates for change in perceptions of Africa.

So, if 'women were everywhere and recorded everything ... explored every facet of photography' [2], why have their stories only been told relatively recently? One reason is that women have too often been relegated to a supporting role, or their contributions have been discussed in relation to a man. Women's work has not been taken seriously or deemed worthy of attention, and doors to institutions, societies and associations have largely been closed to women [3]. Those writing histories have often been men who have promoted a mostly white, Western, male-centric narrative.

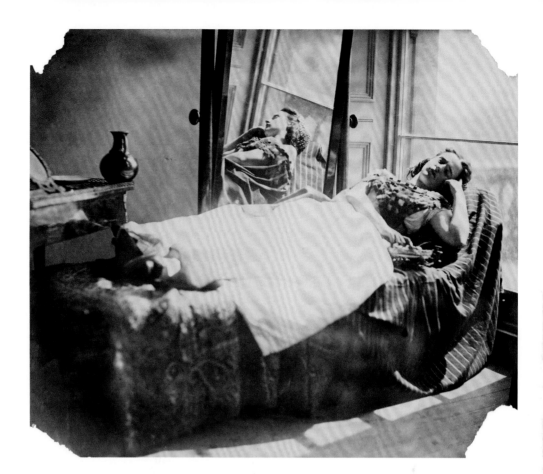

The situation is gradually changing. We are seeing more exhibitions dedicated to women photographers. Foundations, networks, awards and grants that support women in photography are emerging.

This book, while far from definitive, is a small contribution to a far larger movement that is happening. The existing narrative that has gone unchallenged for too long is being reappraised and supplemented. Spotlighting 50 remarkable photographers from all over the world and across the entire history of photography, this book illuminates these women's achievements and endeavours, sometimes in near-impossible circumstances, and in doing so tells a story of how they changed photography for good. There are famous and lesser-known names and women whose work was forgotten or overlooked and has only recently been rediscovered and acknowledged. Some women who feature in the following pages have never been given the proper attention they deserve.

By highlighting, in each chapter, a technique that the photographer used, and in turn offering advice and tips, this book invites readers to celebrate these trailblazers in their own photographic work.

There is much more to be done to restore women photographers and other under-represented figures in photography histories to their rightful place. However, as walls continue to come down and gatekeepers gradually become more diverse, we inch closer to a more representative, inclusive and, ultimately, rich photographic future.

Woman Having an Afternoon Sleep, Lady Clementina Hawarden, c. 1860

VIVIANE

Dutch
Born 1972
Art
Fashion
Portraiture

THE DREAMER

With a penchant for surrealism, Viviane Sassen creates images that seem to straddle dreams and reality, where the 'ordinary and the magical merge.' [4] Often experiencing vivid dreams, Sassen has spoken about the dream world being as important to her as the 'waking world'. Sometimes sketching out her dreams and using them as the inspiration for her images, Sassen has used mirrors, projections, paint, ink, collage and film, as well as photography, to bring her fantastical visions to life.

Shadows, bold colours and abstracted, intertwined figures are all part of the fashion photographer's distinctive visual signature. The years she spent in Africa as a child, in a village in the west of Kenya, had a profound effect on the Dutch photographer, creatively and personally. Sassen and her family moved to the African continent when she was very young. Her father was a doctor and worked in a local hospital. She has spoken about finding her then home country to be a place of 'vivid colours and strong contrasts of light and dark' [5] and shared that she noticed the shapes of figures sheltering from the sun in the shade [6]. Memories of the place she called home, and the dreams she has had about the time she spent there, have shaped her work immeasurably.

The family returned to the Netherlands when Sassen was five years old. It took time for Sassen to adjust to her new life and she has grappled with feelings of familiarity with Africa, but also uncertainty and of feeling like an outsider. We sense this tension in her photographs, which feel complete and full, but can also be unsettling and disorientating.

In the early 1990s, Sassen, who now lives in Amsterdam, studied fashion design before pursuing photography and graduating with a master's degree in fine art. She sent her work to fashion magazines, was published and began to make a name for herself as a fashion photographer of repute, winning all kinds of commissions.

Returning to the African continent with a camera in 2001, Sassen made many portraits, working closely with her subjects and using her beloved strong shadows and light to create off-kilter images that possess a kind of uneasy magic. Her subjects' bodies twist and bend, faces are sometimes obscured and sprawling limbs and fragmented bodies fill the frame. The effect is startling but beautiful. Over the next two decades, she continued to make work in Africa but also in Europe, alternating between constructed images and those that employ a more documentary – albeit surreal – approach. She has also experimented with painting directly on to her photographs.

Sassen's influence on both the art world and the fashion world has been nothing short of era-defining. She has earned a reputation for moving apparently effortlessly between those worlds, something few have done with such grace and skill.

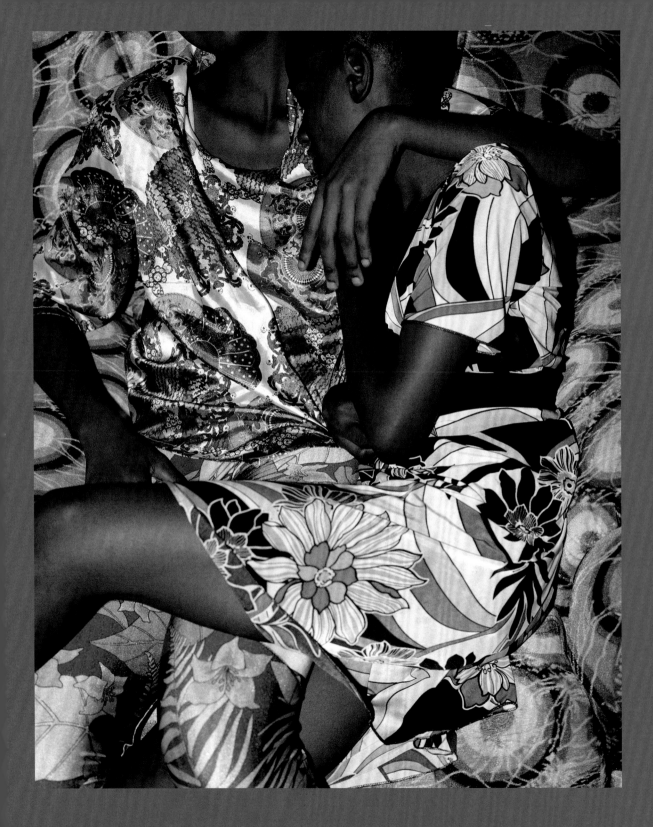

FILL THE FRAME

A technique Sassen often uses is to fill the frame with her subjects, as she has done here. The entire image space is bursting with patterns and limbs. Sassen even allows her composition to spill over the sides of the frame, zooming in and deliberately concentrating the viewer's attention on the exquisitely patterned clothes her subjects are wearing and their intertwined bodies.

Try something similar. Come in close and fill the frame with part of your subject or subjects for dramatic effect.

Solomon's Knot from 'Parasomnia',
Viviane Sassen, 2010

IMOGEN

American
1883–1976
Art
Portraiture
Still life

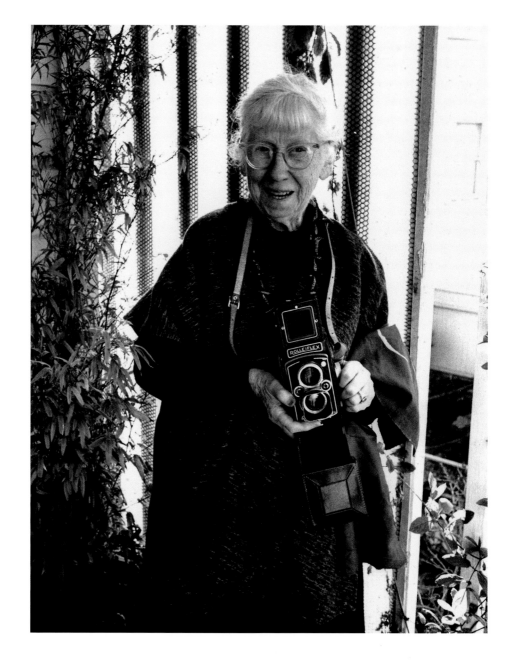

CUNNINGHAM

THE TORCHBEARER

Nicknamed the 'grandmother of photography' for her efforts to advance the medium throughout the 20th century, Imogen Cunningham knew how to create images that made an impact. In her 75-year career as a photographer, she turned her hand to, and made a success of, many genres in photography. She caused a stir with male nudes of her husband, whisked viewers away to dream worlds with her hazy pictorialist portraits, and excited eyes and minds with her experimental modernist botanical studies and exquisite, sensual close-up female nudes. Whether putting the case for why women should take up photography professionally, as she did in her 1913 manifesto, *Photography as a Profession for Women*, or making her own decisions about what or who, how, when and where she would photograph, Cunningham was independently minded and remained true to her art until her death in 1976 at the age of 93.

Born in Portland, Oregon and raised in Seattle, Washington, Cunningham was a creative child who painted and drew from a young age. She became interested in photography at secondary school and used a shed in the family's garden as a darkroom. At 18 she acquired her own camera and went on to study chemistry at the University of Washington after she was advised that this would be useful for a career in photography. After graduating, Cunningham worked with Edward S. Curtis, known for his work photographing Native American Indian tribes, in his Seattle studio. While there, she learnt the art of platinum printing and how to retouch negatives and went on to write a thesis called *Modern Processes of Photography*. After studying in Dresden, Germany, she returned to the United States and opened her studio in Seattle, specializing in portraiture in the pictorialist style. She ran the studio successfully for several years until her marriage to the printmaker and teacher Roi Partridge in 1915. Raising three young sons inevitably meant more time at home, but Cunningham uncovered creative opportunities, photographing plants from her garden. Her fascination with botanical form, or rather, how it could be abstracted when photographed, is evident in the closely cropped images she made. The images with their crisp, clean lines and perfectly balanced areas of light and shade are a far cry from her pictorialist photographs – evidence that Cunningham was a photographer who refused to sit still.

As a founding member of Group f/64, a collective committed to pure or 'straight' photography named after the smallest aperture on a large-format camera, Cunningham moved further away from her early pictorialist work, exploring what the camera's eye could reveal. Her work was published in magazines including *Vanity Fair* and *LIFE*, she did street photography, experimented with multiple exposures, taught photography at the California School of Fine Arts and was exhibited at the Museum of Modern Art, among other places. Boldly living a life in photography that was full and rich, as she urged other women to do, Cunningham set up the Imogen Cunningham Trust to oversee the preservation, promotion and distribution of her work. Although she claimed she didn't know what success was, the woman whose passion for photography never dimmed made sure her legacy would live on.

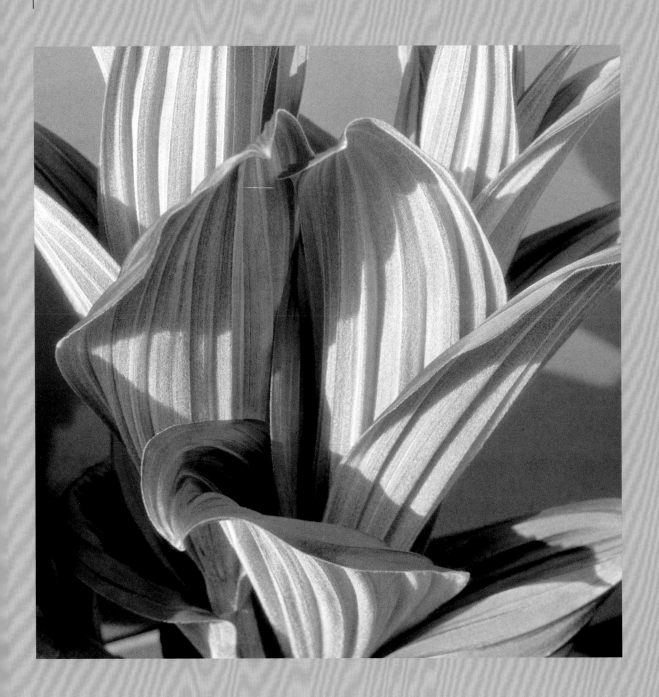

CREATE A DYNAMIC BOTANICAL STILL LIFE

There are various ways of approaching a still-life image of a plant. You could use a macro lens or, if you have a high-resolution camera, shoot wide and crop in. Another way of shooting the image so that everything is in focus is to focus stack – create multiple images focusing on different parts of the subject and blend them in Photoshop. To focus stack, work in 'Manual' mode and use the same exposure for each image. Manually focus on the foreground and take a series of images, slowly moving the focus to different parts of the scene.

How many images you will need depends on your subject, but try two or three to begin with and take more if necessary. Try photographing different plants and create a series of images.

False Hellebore, Imogen
Cunningham, 1926

LIZ JOHNSON

Russian Ghanaian
Born 1964
Documentary
Portraiture

ARTUR

THE CONNECTOR

There is a tacit complicity between Liz Johnson Artur and her subjects, an acknowledgement of the moment a photograph is being made. We sense this when looking at her photographs, especially when a subject looks directly into the camera. In crude terms, the Russian Ghanaian artist's photographs are about connection, not only with her subjects in the moment of capture, but also with the communities they belong to. Sometimes the connection may be a local one, to a community in the artist's neighbourhood of South East London, and on other occasions it takes place further afield. Indeed, Johnson Artur has travelled to, and made work in, Europe, America, Africa and the Caribbean as well as the UK, documenting people who belong to African and Caribbean diasporas.

What makes Johnson Artur's photographs special is the intimacy and authenticity they afford. Getting in close, Johnson Artur, who shoots exclusively on film, somehow manages to establish near instant trust with the people in her images – people she does not usually know. This capacity for immediate connection is even more remarkable when you consider she often works in crowds or busy streets. Whether she is photographing at a family gathering, a carnival, inside a club or a place of worship, Johnson Artur gets to the heart of whatever is happening, effortlessly bringing viewers into the worlds her subjects inhabit through images that are honest and, at times, deeply profound.

Born in Sofia, Bulgaria, in 1964 to a Russian mother and Ghanaian father, Johnson Artur was raised by her mother in what was West Germany. In her late teens, she travelled to New York and, enamoured of the people and culture she encountered, began taking photographs. Her interest in photography remained when she returned to Germany and, in 1991, she moved to London to study at the Royal College of Art. Working as a photographer for seminal magazines *i-D* and *The Face*, Johnson Artur was often on assignments and would make time while she was away to take pictures for herself. Curious about the lives of Black people globally, she is driven by a desire to document the 'normality of black lives and black culture' [7] – everyday, ordinary moments that often go unrecorded. For more than three decades she has been steadily capturing such moments, carefully collating images and ideas in notebooks under the title 'Black Balloon Archive', derived from the song *Black Balloons* by Oscar Brown Jr, recorded by Syl Johnson on the 1970 album *Is It Because I'm Black*.

Often hand printing her photographs, Johnson Artur has also worked with video and has experimented with creating experiential installations that use a variety of approaches, such as displaying neatly ordered images and items on the floor or suspended from the wall or ceiling.

A quote published on the Tate website neatly sums up Johnson Artur's inclusive, collaborative ethos: 'In my work, I like to talk to people, not about them. When people look at my work, they are actually looking at my audience. It's them I would like to reach, but everyone else is invited too.' [8]

USE FLASH TO ACCENTUATE COLOURFUL STREET SCENES

Here, Liz Johnson Artur has created an image with multiple layers or planes, from the girl in the poster on the left, to the woman with a guitar, the little girl to her left and the woman who is cut off on the right of the image. Colour is a major presence in the image, from the pinks of clothes to the colours of the Jamaican flag against a red background.

All of this is accentuated by flash. With a flashgun attached to your camera, try using flash in daylight. Look for areas of colour that you can incorporate into your composition, paying particular attention to the edges of the frame.

No date, no title,
Liz Johnson Artur

SARAH

Ugandan
Born 1980
Art
Documentary
Portraiture

WAISWA

THE COMMUNITY CREATOR

It was while photographing the wedding of a woman from Mombasa in the United States that Sarah Waiswa realized photography could be her future. It was 2013 and Waiswa wasn't yet working as a professional photographer. That would change in the autumn of 2015 when Waiswa decided to leave her day job to pursue a career in photography.

A successful documentary and portrait photographer, Waiswa is also the co-founder of the African Women in Photography network, which celebrates the work of women and non-binary photographers from Africa. The aim of the organization is not only to champion members' work and provide a supportive environment, but also to create educational, financial and professional opportunities.

In her own photography, Waiswa aims to shine a light on important issues on the African continent. She is committed to challenging existing stereotypical narratives about Africa and African people – to explore what she calls the 'new African identity'.

Born in Uganda during the brutal Idi Amin dictatorship, Waiswa and her family fled to Kenya shortly after she was born. In 1999, she moved to the United States – to Kentucky – to study for an undergraduate degree in sociology and a master's in psychology. After living and working in the States for several years, Waiswa returned to Kenya in 2010. She had always wanted to be an artist, but family expectations set her on a different path.

Taking a job in human resources, Waiswa began making pictures on the side. Before long, she began sharing her work online. The feedback was positive, and Waiswa continued to hone her craft, picking up tips on composition and lighting by connecting with other image-makers through the internet. Support came from the Kenyan photography community with whom Waiswa bonded through Instagram. In 2016, Waiswa was nominated for and subsequently won the prestigious Rencontres d'Arles Discovery Award. Ethiopian photographer Aïda Muluneh (p. 36) had put her name and work forward. Waiswa won with her series, 'Stranger in a Familiar Land', which explores the persecution of people with albinism throughout sub-Saharan Africa. Set against a backdrop of the Kibera slums, the work features Florence Kisombe and tells a story of how being rejected by society resulted in a dreamlike existence. The work is not documentary, neither is it a straightforward portrait series. More akin to a fashion shoot with a narrative bent, we see Kisombe, impeccably styled in an elaborate outfit and headdress, seemingly float through her surroundings.

The award helped to put Waiswa on the map and, in the years that followed, she has continued to build her portfolio and profile on the world stage, not only producing work that has agency but helping many other women to do the same.

MANIPULATE ARCHIVAL PHOTOGRAPHS

In her series, 'Lips Touched with Blood', Waiswa worked with archival images taken between 1860 and the 1970s by British travellers in countries of the former British Empire [9]. Waiswa juxtaposed the photographs, which are part of the British Empire and Commonwealth Collection at Bristol Archives, with her own portraits of African people. By changing the figures of the Kenyan people in the archival photographs into blacked-out silhouettes, she redresses the power imbalance between the colonialists who took the photographs and the people being photographed.

Try sourcing archival photographs at a flea market or online. You could draw or paint on the photographs or cut out figures and place card behind the gaps. Think about the message you are trying to convey, as well as the aesthetics of the manipulated image.

Friends?, Sarah Waiswa, 2021

TINA

Italian American
1896–1942
Art
Documentary
Portraiture

24

MODOTTI

THE REVOLUTIONARY

In some of her most affecting photographs, the political activist and photographer Tina Modotti, who is best known for her images of post-revolutionary Mexico, says a great deal with very little. Italian-born Modotti was a master at knowing what to include and what to leave out of the frame. She could create a powerful portrait without showing the person's face, allowing a pair of hands to do the talking instead. It was a technique that held greater significance than just functioning as a neat compositional device. Modotti used her photography to support the socialist/communist cause with which she deeply sympathized. Indeed, Modotti's great skill lay in constructing images that were both formally flawless and politically and socially charged.

Born into a working-class family in Udine in Italy, Modotti emigrated to the United States in 1913. Her father and sister were already living in the country. Still a teenager, she found work as a dressmaker in San Francisco and as a model and an actress in Los Angeles. She modelled for the photographer Edward Weston, who was also her lover, and learnt photography from him. His detailed, modernist and formally rigorous approach was an influence on her own work. In 1923, Modotti and Weston moved to Mexico City, a vibrant, exciting bohemian hub where all kinds of artists and radical thinkers congregated, among them Diego Rivera and Frida Kahlo, with whom Modotti became acquainted. She and Weston ran a photography studio for a time before Weston returned to the United States. Modotti remained in the country and from 1925 became involved in leftist politics, joining the Communist Party in 1927.

Capturing Mexico's vibrant sights and people, Modotti and her photographs became increasingly politically and socially engaged, the tightly framed, compositionally sophisticated still lifes of glasses or roses replaced by those with an overtly political bent. Coming out in support of indigenous workers, Modotti would photograph her subjects, who were often women, with grace and reverence, always picturing them sensitively and with dignity, even if just a labourer's hands and arms were on show. The communist newspaper *El Machete* published her work and she received commissions to photograph Mexican murals. Deported by the Mexican government in 1930, after she was accused of being involved in a presidential assassination plot, Modotti moved to Berlin and then Moscow, where she devoted herself to the communist Comintern social service agency, International Red Aid, for whom she later helped deliver humanitarian and political aid in Spain during the Spanish Civil War. Using a false identity, Modotti was able to slip under the radar and return to Mexico where she lived until her sudden – and as some have speculated, suspicious – death in 1942. Active in photography for just a few years, Modotti made her mark on both photography and history. Her unique take on politically motivated photography, long left languishing in the shadows cast by Weston's light, is now rightfully celebrated.

FOCUS ON YOUR SUBJECT'S HANDS

In this tightly framed image, Modotti draws attention
to a labourer's hands, pictured neatly resting on the
handle of a tool. Modotti understood how symbolism
could be used in her photographs and, here, hands
are symbolic of a life of work and toil. Modotti's
decision to exclude her subject's face adds to the
image's mystique.

For an alternative take on portraiture, arrange
your subject's hands so that they form an interesting
composition. With your camera (ideally with a prime
lens) in hand, move towards and away from the hands
until you have a composition that works. Manually
adjust the focus as you go. Try using a fairly shallow
depth of field to throw the surrounding areas out
of focus.

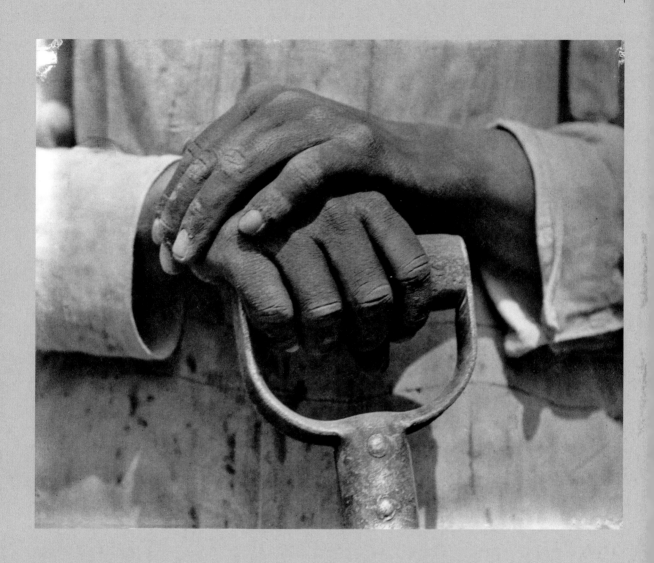

Hands of a Construction Worker,
Mexico, Tina Modotti, 1926

HOMAI

Indian
1913–2012
Documentary
Photojournalism
Portraiture

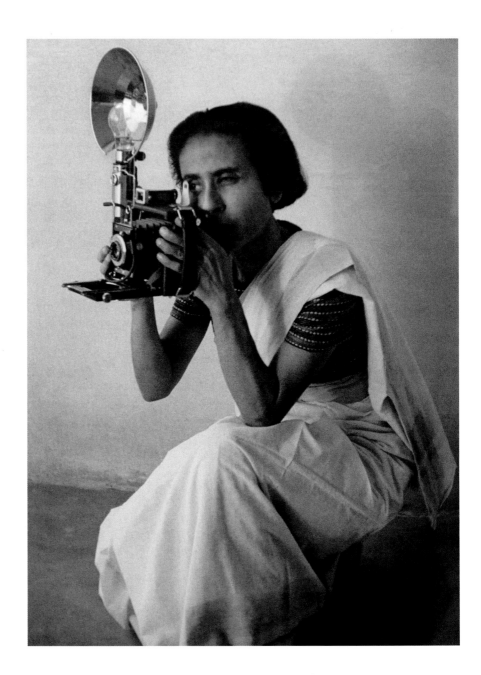

VYARAWALLA

THE DILIGENT DOCUMENTARIAN

Whether she was photographing prime minister Jawaharlal Nehru tenderly embracing his sister or documenting a state occasion, India's first woman photojournalist Homai Vyarawalla knew what she had to do to capture the mood of a moment. Photographing whatever went before her lens with commitment, care and respect, Vyarawalla quietly and consistently built a successful career over many decades before putting down her camera in 1970.

Born into a liberal Parsi community in the western state of Gujarat, India, Vyarawalla spent much of her childhood on the move due to her father's job as an actor in a travelling theatre company. The family settled in Bombay (now Mumbai), and Vyarawalla studied at an art school in the city. From the 1930s onwards, influenced by images in *LIFE* magazine, Vyarawalla began photographing, creating images that include informal, relaxed images of women, sometimes classmates, and members of her community. *The Illustrated Weekly of India* magazine published some of Vyarawalla's work, as did *The Bombay Chronicle*, although her name was not included (the initials of her freelance newspaper photographer husband Manekshaw Vyarawalla were used instead).

The couple moved to New Delhi in the early 1940s where they worked for the British Information Services. Among Vyarawalla's assignments during this time was one where she photographed the vote for the Partition of India in 1947. It wouldn't be the last time she photographed a landmark event. Vyarawalla's work chronicles many milestones in India's modern history, including the first visit by a young Dalai Lama to India in 1956 and state visits by famous figures, among them, Martin Luther King Jr and Vietnamese leader Ho Chi Minh.

Numerous anecdotal accounts tell of an independent woman who would cycle around New Delhi with her camera and photographic equipment. Impeccably dressed in a sari, Vyarawalla always stood out, a lone woman in a sea of male photographers. A dignified and respectful figure, she would wait patiently for the perfect shot and did what it took to nail the picture, even if it meant clambering up a drainpipe.

Her male colleagues thought her a strange sight, she once remarked. 'And in the beginning they thought I was just fooling around with the camera … They didn't take me seriously.' [10] But being a woman had its advantages: Vyarawalla was able to go where she pleased precisely because people did not take her to be a serious photographer. The access Vyarawalla's gender afforded her, particularly when it came to entering intimate spaces, enabled her to create images that many others could not.

Photographing in India before, during and after the country gained independence from Britain, Vyarawalla produced work that is culturally, politically and historically rich. Photography may have been 'just a job', [11] but Vyarawalla embraced her profession wholeheartedly, endeavouring always to be where the action was, eyes open, camera at the ready.

SHOOT FROM A DIFFERENT ANGLE:
GET DOWN LOW

Vyarawalla's photographs frequently bring viewers into the centre of the action. Often making bold compositional choices, she would shift her position if it meant getting a stronger shot. Much has been made of the framing in her well-known photograph of the Victoria Terminus, Bombay – namely, the low angle she photographed from and how the cart in the foreground frames the man in the centre.

On a busy street, with your camera to your eye, crouch down and notice how the scene looks. Move the camera around, noticing the various images that come and go. Use street furniture to frame passers-by and think about how you can compose your image to lead the viewer through the scene and create a sense of depth.

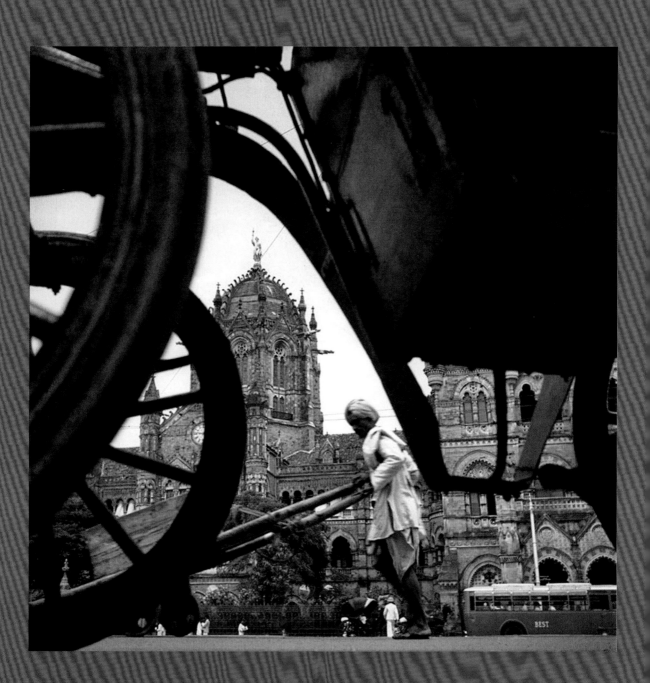

Victoria Terminus,
Homai Vyarawalla, 1940

ALICE

American
1866–1952
Documentary
Portraiture
Street

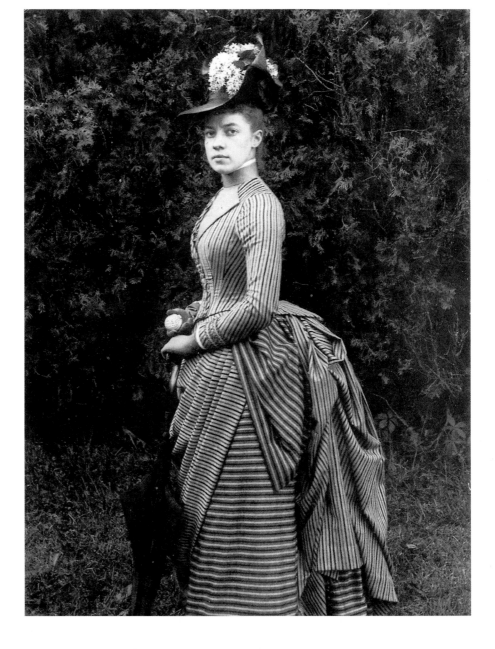

THE CONVENTION CHALLENGER

A fiercely independent woman who defied traditional Victorian conventions, Alice Austen pursued her craft with passion and vigour. Born in Staten Island in 1866, she was, technically, an amateur as she did not make her living from photography. However, she was prolific, producing some 8,000 photographs in her lifetime. She also took the unusual step of copyrighting some of her work and accepted the occasional commission – illustrative of her self-reliant and free-spirited attitude to life and photography.

Employing a documentary approach, which was uncommon among Victorian women photographers at the time, Austen photographed the world around her, from the immigrant populations of her home city of New York to leisure activities and family events at her beloved home, Clear Comfort, where she later lived with her partner, Gertrude Tate.

Drawn to the ebb and flow of life on the bustling streets of New York, she produced images of pedlars and newspaper vendors, street sweepers and hansom cab drivers, and was as comfortable photographing in an urban environment as she was in more intimate domestic settings. Using a heavy wooden box camera, Austen, one of America's first female photographers to work outside the studio, would often lug her photographic equipment around on her bicycle. This was no mean feat as it weighed around 23kg (50lbs). She then developed and printed her images at home, in the darkroom she had created in a hallway cupboard.

Among Austen's most critically acclaimed works are those depicting groups of people, often including herself and frequently featuring women. Her photographs of female friends and contemporaries are playful and tender. They provide a valuable and fascinating record of intimate relationships between Victorian women that is rarely seen. Notably, Austen produced images that challenged traditional gender roles of the day and defied expectations of how women should behave. For example, she photographed herself and her companions dressed up as men, sharing a bed and in undergarments, smoking cigarettes.

It is hard to overstate how groundbreaking these images were. Victorian women were not usually depicted like this, and most female photographers did not approach photography in the bold way that Austen did. Austen's fearless 'rule-breaking' approach and her desire to push boundaries make her work especially exciting and important. Indeed, when *LIFE* magazine published an article about an exhibition of her work in 1951, it described Austen as 'America's first great woman photographer.'[12]

Austen and Tate lived together until 1945 when Austen, who had lost most of her wealth in the stock-market crash of 1929, moved to the Staten Island Farm Colony, a poorhouse. She died in 1952. Austen's former home is now the Alice Austen House, a museum which houses her archive and works to preserve her legacy. Since 2017, it has been a designated national site of lesbian, gay, bisexual, transgender and queer (LGBTQ) history.

SHOOT INFORMAL GROUP PORTRAITS

Many of Alice Austen's most impressive images feature groups of people having a good time. Try posing a group of friends or family members in an outdoor setting. Position your subjects to ensure the composition has variety and looks natural. Have people standing, sitting, crouching or leaning into the frame. Choose your background carefully, avoiding distractions.

Use an aperture of f/5.6 to f/8 and a shutter speed of 1/200th second if you are shooting handheld to ensure everyone is sharp. Be confident when directing your subjects and make it fun! Group portraiture is about collaboration, so involve your subjects in making the picture.

Julia Martin, Julia Bredt and Self, Dressed Up, Sitting Down, Alice Austen, 1891

AÏDA

Ethiopian
Born 1974
Art
Photojournalism
Portraiture

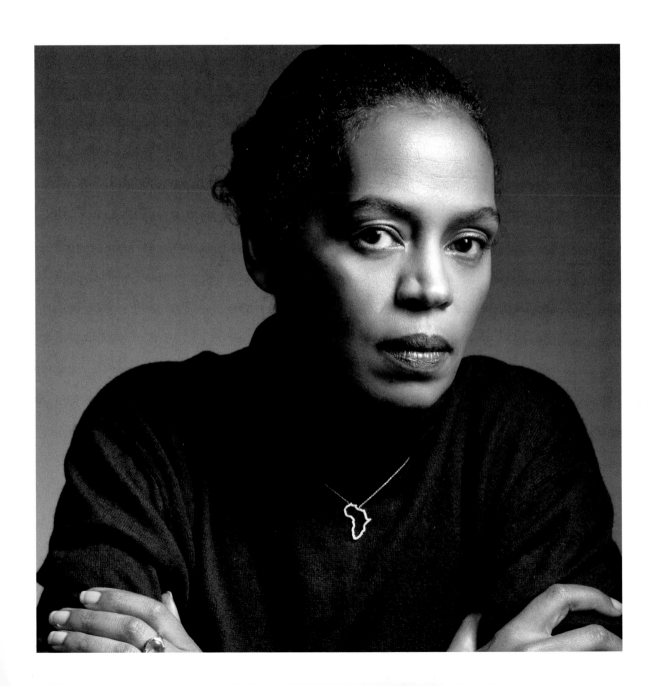

MULUNEH

THE ADVOCATE

Aïda Muluneh is a photographer and an artist who uses her art to advocate for change in the portrayals of Africa: stereotypical depictions that fail to recognize the diversity of the African continent. Her work, with its vibrant colours, striking costumes, makeup, body painting, styling and set design, is immediately recognisable. She works as a filmmaker might work, with actors, lighting and a team. Often, she starts by sketching out an idea for an image before creating a storyboard and embarking on an intensive process of research and preparation to bring that vision to life. Paying particular attention to pose and the way her subjects look into the camera, Muluneh brings together many facets to paint a picture of her feelings. These include the current state of Ethiopia, where she was born, and of the world, but also historical 'challenges' that create an emotional connection with her audience. Drawing influence from cultural traditions, including body ornamentation of her country and other nations, Muluneh seeks more diverse impressions of Africa that go beyond war, famine and other crises.

Born in the Ethiopian capital of Addis Ababa, Muluneh took up photography as a teenager while living in Calgary, Alberta, Canada. Noticing the limited scope of international press coverage of her home country, she was moved to act. Studying at Howard University in Washington, D.C., majoring in film, Muluneh began her career as a photographer for *The Washington Post* in the early 2000s. Finding that photojournalism limited the thoughts and ideas she wanted to express, Muluneh decided to take the route of fine art photography, producing work that is both aesthetically appealing and serves as a call for change.

Returning to Ethiopia in 2007, Muluneh continued to make work that drew heavily on her own experiences in her birth country and elsewhere to explore issues to do with history, politics and gender, as well as the impact of the climate crisis. Daily life in Addis Ababa – the people, streets and light – as well as her experiences as a photojournalist, have fed into her artwork. One of her most well-known series is 'Water Life' (2018). In this work, commissioned by WaterAid and supported by the H&M Foundation, Muluneh highlights the lack of access to water in Ethiopia and the effect this has on gender equality.

Often using colour and objects symbolically, Muluneh has also incorporated her own drawings into her work. She is interested in finding new ways to explore the physical process of constructing an artwork, which has led her to use acrylic paint. Hugely supportive of other African photographers, Muluneh is the founder of Addis Foto Fest, a biennial international photography festival – the first in East Africa – which provides a platform for showcasing the work of photographers from Africa. In 2019, she co-curated the Nobel Peace Prize exhibition at the Nobel Peace Center in Oslo – the first Black woman to do so – and in 2022, building on her work with Addis Foto Fest, she launched Africa Foto Fair in Abidjan, Côte d'Ivoire, where she now lives. Continuing to promote the work of others, as well as take her own visual language in new directions, Muluneh is committed to 'breaking the rigid rules of photography'[13].

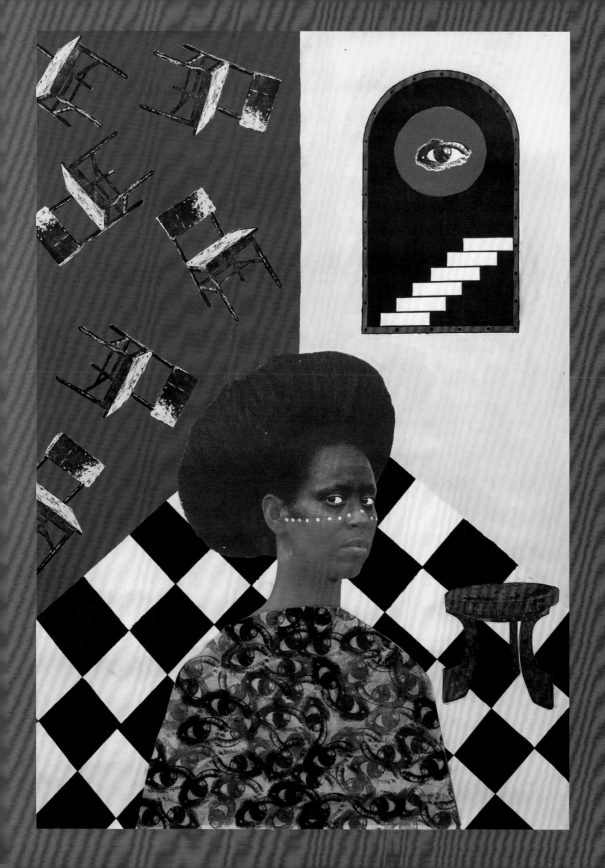

PAINT ONTO YOUR PHOTOGRAPHS

Muluneh first used paint in her work many years ago. Her earliest experiences of photography were in the darkroom, so printing has always been an integral part of her process. Working on a print was an obvious next step. 'It is not a decision but a natural path towards expanding my self-expression into a new approach to photography,' she has said.

Try printing out one of your photographs – it could be a portrait or a landscape or something else entirely – and have a go at painting on the surface of the print. Think about the areas you want to accentuate. Add a little amount of paint to begin with and build it up gradually.

Walls of Silence,
Aïda Muluneh, 2022

ILSE BING

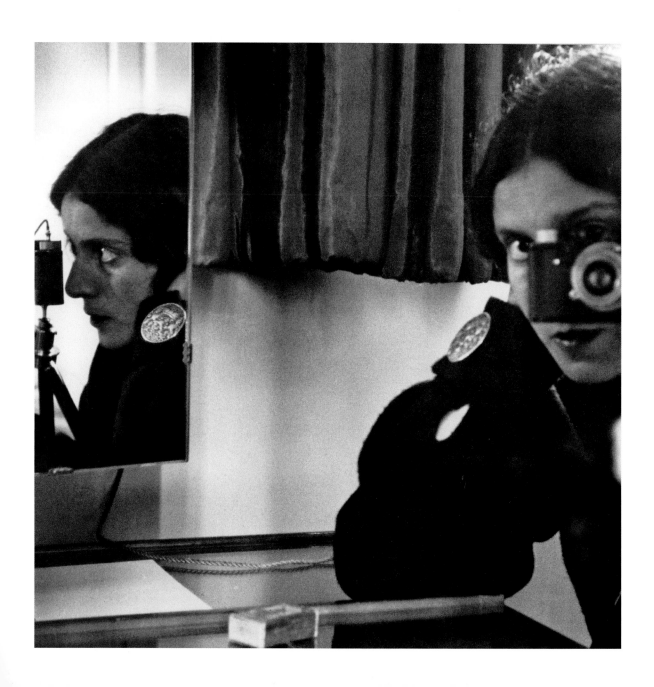

THE LEICA LEGEND

Today, when we are used to seeing images of almost anything, it is hard to imagine photographs of puddles or leaves as being surprising, but in the 1930s, when German photographer Ilse Bing was working, such subjects prompted head-scratching responses. 'What we photographed was new, too – torn paper, dead leaves, puddles in the street – people thought it was garbage!' Breaking the rules, Bing said, 'opened the doors to new possibilities.' [14]

Indeed, Bing, one of the interwar period's greatest image-makers, knew a thing or two about challenging expectations of what photography could be and do. Working at a time of huge experimentation across the visual arts, Bing, who was born into a Jewish family, was as cutting edge as Man Ray, her name (and work) included in the same breath as the great master. A new modernist visual language was rapidly emerging across painting, sculpture, design and architecture, as well as photography. For photographers, this meant experimenting with strong lines and abstraction and abandoning a soft-focus approach in favour of sharply focused images. This so-called 'New Vision Photography' saw photographers play with perspective and light as they indulged photography's untapped artistic potential. New approaches to image-making were rife, including photograms and photomontages, and the invention of the revolutionary Leica, a 35mm hand-held camera, allowed photographers to work more nimbly and effectively than ever before.

It was an exciting time to be a photographer, 'a time of exploration and discovery' [15], Bing recalled, and she made the most of it. Having switched to art history from a degree in mathematics and physics at the University of Frankfurt, she went on to pursue a doctorate in the same subject area. Using a camera purely practically at first to create illustrations of buildings for her thesis, Bing found photography to be a medium that she could make her own. With her Leica camera in hand, she began working as a photographer in Frankfurt before moving to Paris in 1930.

Inspired by the work of Florence Henri (p. 56), Bing turned her hand to many genres, including documentary, portraiture, architecture, advertising, dance, theatre and fashion photography. She was published in German and French newspapers and magazines including *Harper's Bazaar* and *Vogue*. Regarding the camera to be an extension of her vision, Bing, who was technically adept as well as artistically minded, developed a style that combined shadows with unusual shooting angles and contrasted areas of light and dark in surprising ways.

After emigrating with her husband to New York in 1941, Bing continued to make photographs for the best part of two decades, later using a medium-format Rolleiflex camera. Towards the end of the 1950s, she began experimenting with colour film before giving up photography to pursue poetry, drawing and collage. Exhibited in both the US and Europe in her lifetime, Bing was a photographer who spotted and seized, with both hands, photography's near-endless potential as a thrilling new art form.

USE SHADOWS TO CREATE A DYNAMIC STREET SCENE

Received wisdom is to avoid photographing in harsh lighting conditions because doing so will create images that have too much contrast (a loss of detail in the darkest and lightest areas). Shooting in the middle of the day in strong sunlight, however, can give you dramatic shadows to play with.

On a sunny day, head to your local town with your camera and pay attention to the interplay of shadows. Look for strange juxtapositions and abstract-looking scenes. Make sure any shadows you include in your image are distinct. In other words, try to avoid creating confusing areas in the composition. Convert your files to black and white and play with the contrast.

*Frankfurt, Hellerhof Siedlung, mein
Schatten mit Architekt*, Ilse Bing, 1930

ANNA

English
1799–1871
Art
Cyanotypes
Scientific

THE BOTANIST

Born in Kent, England, at the end of the 18th century, Anna Atkins famously used the cyanotype photographic process to record British algae and other plants, and privately published the first book to be illustrated using photography. A botanist and scientific illustrator, Atkins was the only daughter of the esteemed chemist, John George Children. Her father, who was a member of the scientific academy, the Royal Society, encouraged his daughter's interest in science, introducing Atkins to important scientific thinkers and inventors of the day – an unusual move, since women were generally not welcome in such circles.

Through her father's connections, Atkins met the famous photography inventor, William Henry Fox Talbot (1800–1877). Impressed by his paper photography process, Atkins swapped drawing for photography as her chosen method of recording her botanical specimens, not least because it was far quicker to produce the detailed images she desired.

Notably, Atkins did not use a camera to create her artful yet scientific images, although she did own one. Instead, she made photograms – images created by placing objects directly onto light-sensitive paper – and used the cyanotype process, invented in 1842 by astronomer and physicist, Sir John Herschel. The process, which gives distinctive blue images, involves treating a surface (paper) with light-sensitive iron salts (a combination of solutions of ferric ammonium citrate and potassium ferricyanide) and exposing it to ultraviolet (UV) light. Atkins made negative images by placing her botanical specimens directly onto the specially prepared light-sensitive paper, which was then exposed to light. After a time, the paper was washed in water. Atkins created hundreds of cameraless prints, which she collated in a three-volume book called *Photographs of British Algae: Cyanotype Impressions*, between 1843 and 1853. Atkins self-published her book, which features more than 400 plates, distributing copies amongst friends and colleagues. It is widely regarded to be the first photographically illustrated book.

Atkins' publication is impressive because of the way she merged science with art in her expressive yet informative images, but it also opened up new ways of thinking about how photography could be used to illustrate books. Those who made illustrated publications were no longer limited to using engraving and woodcut printing processes. Photography's potential to render images in print, specifically for scientific publishing, was thrown wide open.

After completing her book on British algae, Atkins went on to use the cyanotype process to make images of other plant life, including many types of ferns, grasses and flowers. She continued to play with the artistic properties of her images, not least in terms of tone and form. Atkins' images are groundbreaking because they are more than scientific records: they expertly demonstrate how photography can be used artistically and expressively to interpret the world.

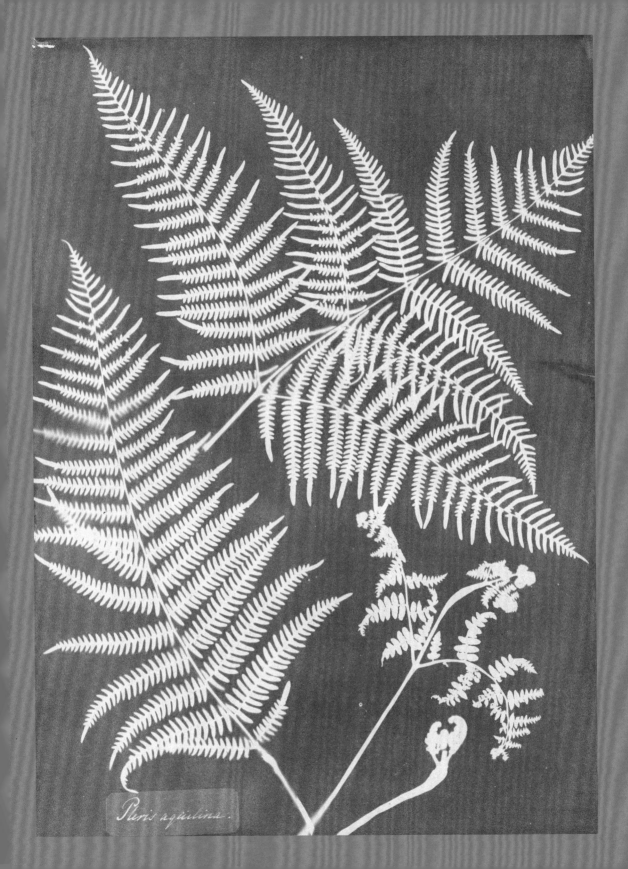

Pteris aquilina.

MAKE YOUR OWN CYANOTYPE USING PRE-PREPARED PAPER

Cyanotypes are distinctive photographic prints featuring a white subject on a blue background. They are very easy to make using pre-prepared cyanotype paper. In addition to your paper, you will need a piece of card, a piece of acrylic or glass, some masking tape, or large bulldog clips, plus the items you wish to use to create your composition, which could include flowers, leaves, feathers or small objects, such as keys, scissors and coins.

Place your sheet of paper onto the cardboard and arrange the items on top. Only use the paper when you are ready to make your print and keep the other sheets away from light when you're not using them. Position the piece of glass or acrylic on top of the paper and fix with bulldog clips or tape. Leave your paper in direct sunlight for at least five minutes (longer on an overcast day), then gently wash your sheet of paper for at least a minute in cold water. Leave to dry for a few hours. Watch the rich blue colour return!

Pteris aquilina,
Anna Atkins, 1851

RAHIMA

Nigerian
Born 1986
Art
Documentary
Mixed media

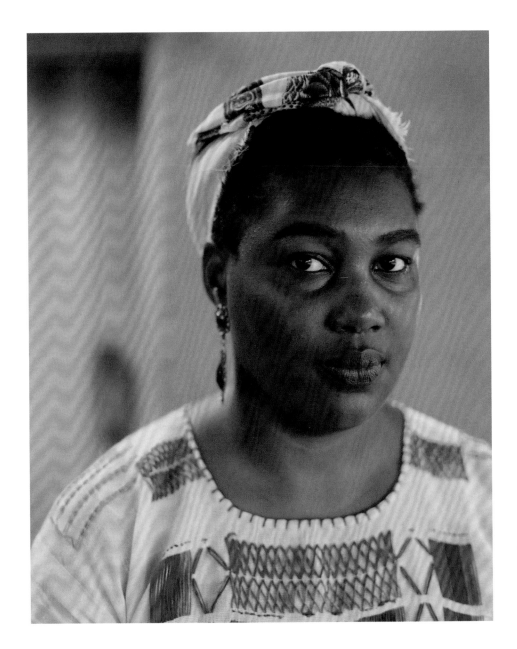

GAMBO

THE COLLABORATOR

One of many threads that runs through Rahima Gambo's immersive work is how a person or people pick up from where they left off after experiencing extreme trauma. It is a theme that Gambo explores in relation to the experiences of students affected by the Boko Haram conflict in north-eastern Nigeria where hundreds of teachers and students have been injured, abducted or killed by the militant organization who want to create an absolute, 'pure' Islamic state without Western influence. True to its name, Boko Haram roughly translates as 'Western education is forbidden'.

Gambo, who has a background in journalism, does not take a traditional documentary photography approach. Instead, she combines photographs, text, video, installation, sound and illustrations to tell stories that are not 'about' her subjects' experiences but, rather, are made with them. This inclusive approach is inspired by the anthropologist and film-maker Trinh T. Minh-ha's idea of 'speaking nearby', which avoids direct documentation and the tendency to explain or to 'speak about' something or someone in favour of a more indirect approach. For Gambo, it is about moving away from traditional linear narrative photojournalism and towards an expanded visual language that is collaborative, playful and does not impose meaning.

Gambo, who was born in London and moved between Nigeria and the UK from the mid-1990s, studied for a degree in development studies at the University of Manchester. A master's in gender and social policy from the London School of Economics followed, and a second master's in journalism at the Columbia Graduate School of Journalism in New York in 2014. Sensing a tension between the traditional or accepted journalistic approaches that were being taught and her own outlook and experience, which she describes as 'multi-directional' [16], she began to make work that comes from a documentary tradition but feels more expansive, multi-dimensional, experimental and conceptual. An early project was *Education is Forbidden* (2015–2016), which combined text with images, illustrations and video. The long-form multimedia project that Gambo described as 'living' online and comprised chapters, told a penetrating story of the impact of Boko Haram's actions on students at the Shehu Sanda Kyarimi Government Day Secondary School, which was targeted by insurgents in 2013.

Another project, 'Tatsuniya' (2017–), explores new storytelling approaches that have collaboration and play at their centre. Gambo made the work, which comprises choreographed stills and film, with students from the same school during storytelling workshops. The project's title means 'story', 'tale' or 'riddle' in Hausa. Sequences of images unfold as though in a dream and a narrative weaves itself into existence. Tatsuniya Artist Collective is a registered organization that represents the 20 original student collaborators who featured in 'Tatsuniya'. Founded through the visual storytelling workshops Gambo led, the collective, the artist explains, is an artists' studio and a space where members can gather, collaborate, discuss issues, find support and initiate creative projects.

SEQUENCE IMAGES TO TELL A STORY OF A MOMENT

Concerned with questions of what it means to tell stories with the medium of photography and to be a photographer in the spaces she occupies, Gambo is breaking new ground, not just photographically, but also in terms of the important stories she is committed to telling.

One of Rahima Gambo's techniques involves using several images to create poetic sequences. Gambo used this approach when photographing students playing a popular Nigerian game in their classroom in Shehu Sanda Kyarimi school, Maiduguri (pictured). Here, Gambo elongates time or creates a sense of time slowing down.

You could try something similar. Instigate a scenario, some kind of shared activity, involving friends or family. Photograph the scene from different angles using a fast shutter speed to freeze movement. Make a contact sheet of your images, circling the strongest. Cut out those images and play around with the order. Try to create a sense of momentum. Make sure there is enough variety in the shots you choose and think especially about how you start and end your sequence.

playing slowly

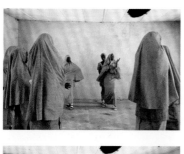
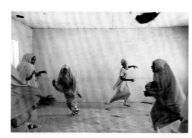
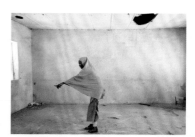
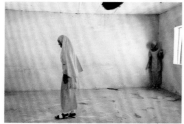
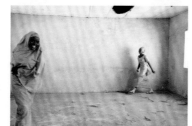
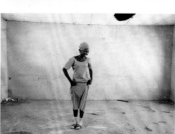

From 'Tatsuniya',
Rahima Gambo, 2020

PUSHPAMALA N.

THE STEREOTYPE CHALLENGER

The photo-performance artist Pushpamala N. says her work was not taken seriously in her home country of India for a long time because it used performance, humour and fiction. [17] Now she is one of India's foremost artists. At the core of Pushpamala's work is an interest in, and interrogation of, the idea of the 'Indian woman', which she probes by wittily deconstructing and subverting common cultural stereotypes. She does this by channelling references from colonial-era ethnographic photography, art, cinema and other areas of popular culture to reconstruct elaborately staged scenes. If her work has a sculptural dimension to it this is not accidental. Pushpamala studied sculpture at The Maharaja Sayajirao University of Baroda, but by the late 1990s she had switched to photography, creating what she calls 'photo-romances' featuring herself adopting different personae and acting out various scenes. In early works such as *Phantom Lady or Kismet*, props, costumes and locations are brought together to create narrative works that nod to the black-and-white film-noir genre.

In her well-known series, 'Native Women of South India: Manners and Customs' (2000–2004), the artist, who is based in Bangalore, collaborated with British photographer Clare Arni to create a performative body of work that critiques 'types' of women familiar in Indian culture. Divided into four subseries with Pushpamala playing roles that include a Hindu goddess and an Indian film star, the work places characters – female archetypes, both real and fictional as identified by the artist – within carefully stage-managed spaces to recreate familiar art historical, mythological and religious scenes. In her artworks, Pushpamala draws attention to the fact that identity is itself a construct, but one that is often assigned rather than created by the person or people to whom it is attached [18]. Objectifying herself as she does through masquerade – always on her own terms – Pushpamala conversely creates images that have a sense of agency. There is a knowingness in the work, evident in the sly looks to camera. The series, which is something of an inventory of images and in a sense encyclopaedic, the artist has said, also references the so-called 'Zenana' photography studios, set up for women largely by women, which existed in 19th-century India.

At once playful and wryly humorous, the constructed images in the 'Native Women of South India' series not only invite us to question received notions of Indian women, but also to consider the role photography plays in the construction of stereotypes. Photography's artifice and its ability as a classification device is evident, for example, in the sepia-toned images that feature Pushpamala on a set kitted out with apparent measuring tools, including an arm-stand and a gridded backdrop. The scene mocks set-ups and approaches used in 19th-century ethnographic portraiture by British colonialists who deployed the camera as a dehumanizing device to classify, control and subjugate. Tapping into what she has called a shared 'cultural memory' through her chosen medium of photography, Pushpamala invites viewers to reassess ingrained assumptions and expectations, questioning the nature of representation itself.

GO TO TOWN WITH A CREATIVE BACKDROP, PROPS AND PLENTY OF COLOUR

On page 72, we talk about Madame Yevonde's work and how she used props to create a portrait of herself that offers the viewer an insight into who she is as a person. Pushpamala's work is about challenging cultural stereotypes and inviting audiences to see differently.

Stage an image using costume, props and set design to encourage viewers to question the beliefs they hold about a persona or idea. Hint at the image's construction and the constructed nature of photography itself by including the edge of a stand, a Colorama (background paper) or the corner of a light.

Yogini F-24 from 'Native Women of South India: Manners and Customs', Pushpamala N., 2000–2004

FLORENCE

American-born Swiss
1893–1982
Art
Portraiture
Still life

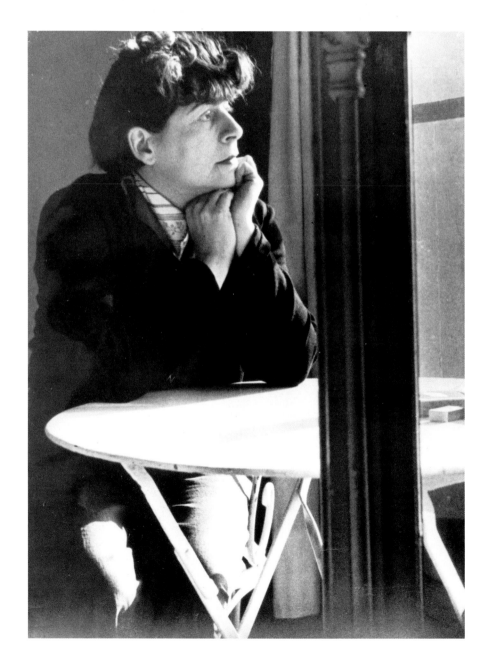

HENRI

THE BAUHAUS QUEEN

Whatever Florence Henri fixed her lens on – a portrait, nude, still life or advertising image – was transformed into a masterclass in the handling of form, shape, light and composition. Even the self-portraits she made feature dramatic lines that artfully deconstruct space. So compelling were her photographs, which drew from cubism and constructivism, that in 1928 the great Bauhaus visionary and Henri's mentor, László Moholy-Nagy, declared that her images steered photographic practice into 'a new phase, the scope of which would have been unimaginable before today.' [19]

Born in New York to a French father and a German mother, Henri was a key figure in avant-garde photography from the late 1920s onwards. Spending her formative years in various European cities following her parents' deaths, she learnt piano and became a proficient pianist before turning her attention to painting. Studying in Berlin for a time, and in Paris under masters who included the painter Fernand Léger, Henri's abstract artworks, which included collages as well as paintings, were concerned with the depiction of space, a preoccupation she would later explore through photography.

A spell at the Bauhaus art school in Dessau in 1927 proved pivotal for Henri, who took up photography, encouraged by the photographer Lucia Moholy. 'What I really want to do is compose the image, as I do in painting,' Henri famously said. What this meant in practice was the construction of images that were the result of absolute artistic control, where composition was paramount and photographic form could be bent to the artist's will. Whether it was a tightly framed and strongly lit portrait, or an intricate still life comprising multiple intersecting or overlapping planes, Henri made sure that the viewer saw exactly what she wanted them to see.

Mirrors were a key compositional device that allowed Henri to play with photographic space and, in turn, create visually complex, layered images that play with realism and abstraction. Initially, she used mirrors to produce a reflection of herself or another figure, but the mirrors soon began to feature more prominently – Henri used them to create and combine multiple fragments of images within an image. Indeed, Henri's era-defining photographic works are characterized by their fragmented appearance, where bold framing and bisecting lines are recurring motifs. Henri created photomontages and used multiple exposures to achieve her signature fragmented style. Her work was in keeping with the principles of the New Vision, a photography movement with a connection to the Bauhaus, which favoured experimental approaches in image-making, not least the use of structural lines that echoed modernist architecture, close-up shots, areas of shadow and unusual viewpoints.

Setting up her own photography studio in Paris in 1929, Henri also taught photography, her most famous students being Gisèle Freund and Lisette Model who would join Henri as important figures in histories of photography.

PHOTOGRAPH A STILL LIFE WITH MIRRORS

On a tabletop covered with a dark-coloured
piece of fabric and against a dark backdrop,
arrange flowers, pieces of fruit and two or three
medium-sized pieces of mirrored acrylic sheets.
Where you decide to place them will depend on
the composition you're after, but try to position
the items to give a sense of depth and at
different angles.

Look for good balance across the frame.
Place your camera on a tripod and position
a light overhead. Use a small aperture to give
a good depth of field.

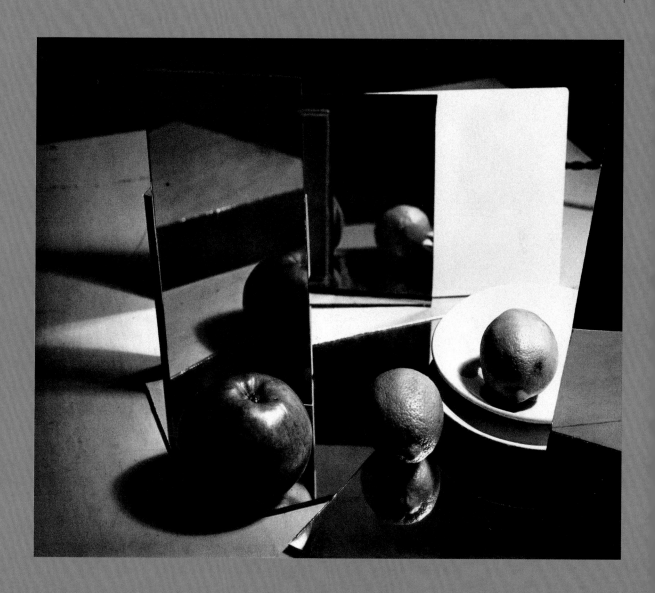

Composition Nature Morte,
Florence Henri, 1929

NADINE

British
Born 1992
Art
Fashion
Portraiture

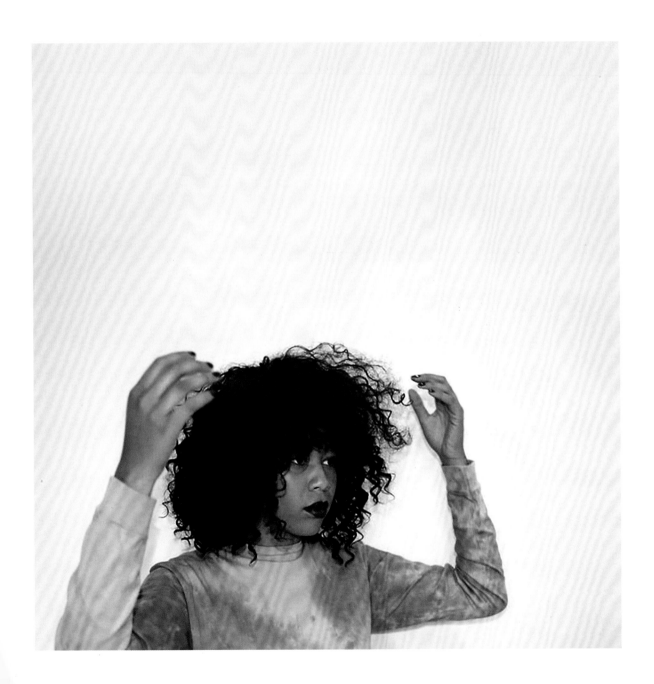

THE HISTORY MAKER

Few women photographers can say that they have made history before the age of 30. Nadine Ijewere can. The South London-born photographer was just 26 when she photographed the cover image for the January 2019 issue of *British Vogue*, making her the first woman of colour to shoot the cover of any issue of *Vogue* globally in the magazine's 125-year history. Her history-making cover story in a special issue dedicated to, in editor Edward Enninful's words, 'work by the best of photography and styling's new guard' featured British Albanian singer Dua Lipa, American model Binx Walton and Guyanese British actor Letitia Wright [20].

Before the issue's publication, Ijewere, who studied at London College of Fashion, had been building her name in the fashion industry, often photographing her mixed-race friends and posting the images on social media, where she was gathering a following. Overnight, she became a global sensation.

Creative from a young age, Ijewere, whose father is Nigerian and mother is Jamaican, studied photography alongside A levels in science and maths. She had planned to go into medicine but chose to pursue photography instead. Spurred on by what she saw as a lack of diversity in fashion magazines and drawn to what she calls 'non-traditional faces', Ijewere began making images that embraced less conventional types of beauty and, in turn, challenged traditional beauty ideals. Women often feature, particularly women of diverse ethnic backgrounds. As time has gone on, Ijewere has continued to subvert conventional depictions of beauty by photographing plus-size models and people from a wide range of backgrounds.

Her dynamic style has developed organically, she says, and often includes a sense of movement, created by playing with perspective or the camera angle, or the way clothes tumble and fall or the model moves their body. An Ijewere image will frequently lead the eye around the frame, across and through the composition, almost to the point that the still image no longer feels static. Colour is an important element too and she often plays with warm hues or contrasting colours.

Committed to producing work that 'speaks' to her and determined to never change what she does to fit someone else's vision, Ijewere is one of fashion's most in-demand young photographers. Despite her rapid rise to fame and the attention that has come with that, she remains grounded, humbly saying that she hopes her achievements will open doors for others in an industry that, although it has made progress, still has some way to go to achieve greater diversity, both behind the lens and in front of it.

SHOOT PEOPLE UPWARDS FROM A LOW ANGLE

In Nadine Ijewere's arresting image *Spring Dress* with Ayobami Okekunle, Elibeidy Dani, Huan Zhou and Yoonmi Sun for *WSJ Magazine*, it is as though we are lying at the models' feet and looking up. Fashion photography is full of off-the-wall approaches, but it's not often you see garments depicted in such a unique, dynamic way.

Whether you are photographing a single person or a group, inject surprise and excitement into your portrait images by positioning yourself and the camera on the ground and shooting up. Use a wide-angle lens and shallow(ish) depth of field. You could also try using some flash fill on the models' faces or use a white reflector to bounce light back into their faces.

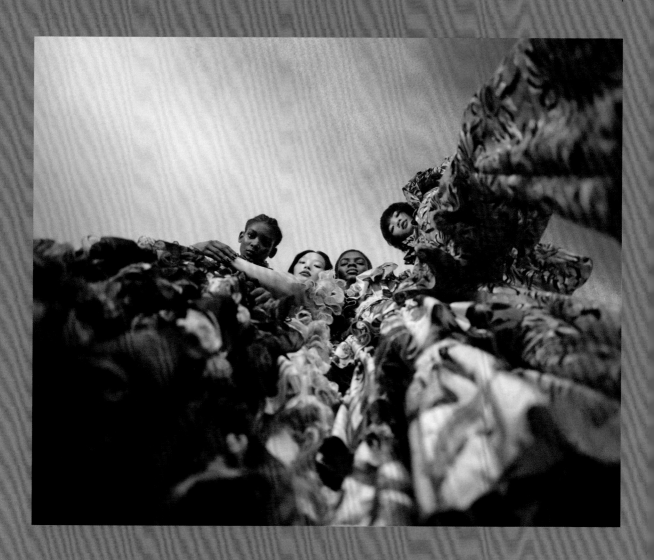

Spring Dress for *WSJ Magazine*,
Nadine Ijewere, 2019

JESSIE TARBOX

Canadian-born
American
1870–1942
Documentary
Portraiture
Press

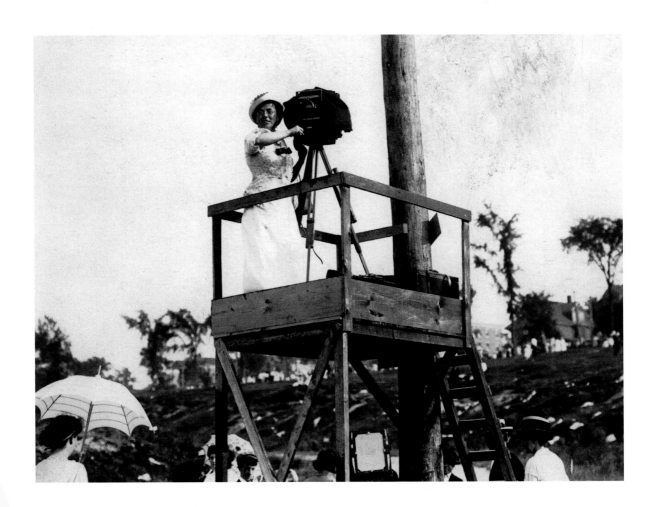

BEALS

THE TENACIOUS NEWSHOUND

A woman who climbed ladders to get the shot and photographed from a hot air balloon, Jessie Tarbox Beals is not well known today, but she lived her life with gusto, always pushing herself in new directions and never taking no for an answer. An unapologetic self-publicist who staged photographs of herself to use as publicity material, Tarbox Beals was one of the first female photojournalists in the United States and is believed to have been the first woman to take photographs at night, sometimes using flash powder to illuminate a scene. Self-taught, Tarbox Beals would lug her 8×10-format camera wherever the story took her. She went against convention by enlisting her husband, Alfred, as her assistant, teaching him to process her plates and make prints for her.

Always willing to turn her hand to whatever newsworthy event needed covering, Tarbox Beals photographed everything from street life to murder trials, animals, architecture, indigenous people, artists and much more. She was unusual in that she shot widely while most other women chose to set up portrait studios and focus on portraiture. Her willingness to cover any subject helped her to establish a successful career, although she later expressed regret for not having had a specialism.

Beginning her profession as a teacher, Tarbox Beals began making pictures after acquiring a basic camera in 1888. Everyday happenings, friends and family were her subjects, as they were for many camera-wielding Victorian women amateur photographers. Photographing local events and making portraits as a side hustle, ('hustle' was in fact one of the words she used when describing the skills she believed women needed to pursue and succeed at news photography), Tarbox Beals left teaching in 1900, achieving her first properly credited published photographs in a local newspaper later that year. Within a couple of years, she was working as a news photographer full time, including for two local newspapers in Buffalo, New York – *The Buffalo Enquirer* and *The Courier*. Forthright and not short on self-belief and confidence, Tarbox Beals elbowed her way into the St Louis World's Fair in 1904 (the pass she had been granted only provided limited access), becoming the official photographer for several newspapers and the event itself.

Nimbly navigating what was becoming an increasingly competitive field, Tarbox Beals ran a studio with her husband for a time, also turning her hand to advertising photography and gardens and interiors. Much of Tarbox Beals' work has sadly been lost to time and her name fell into obscurity after her death in 1942. That is now changing thanks to individuals such as the photographer Alexander Alland who published the biography, *Jessie Tarbox Beals: First Woman News Photographer* in 1978, and institutions who are working to ensure her name is not lost to history.

PHOTOGRAPH AT NIGHT WITH FLASH

That Jessie Tarbox Beals went out at night to take photographs is extraordinary, not least because her glass-plate camera would have been heavy and cumbersome to transport.

Photographing after dark today is much more straightforward, of course. With your camera on a tripod and a flash attached via the hot shoe, set up in a location that interests you. Play with the framing until you are happy. Think about the areas you want to illuminate with flash and which would be better left in shadow. Experiment with different shutter speeds to balance the flash with ambient light. Convert your colour files to black and white and play with the contrast in Photoshop to accentuate the most important parts of the scene.

Shaw Memorial at Night,
Boston, Massachusetts,
Jessie Tarbox Beals, 1906

LYNSEY

American
Born 1973
Documentary
Photojournalism
Press

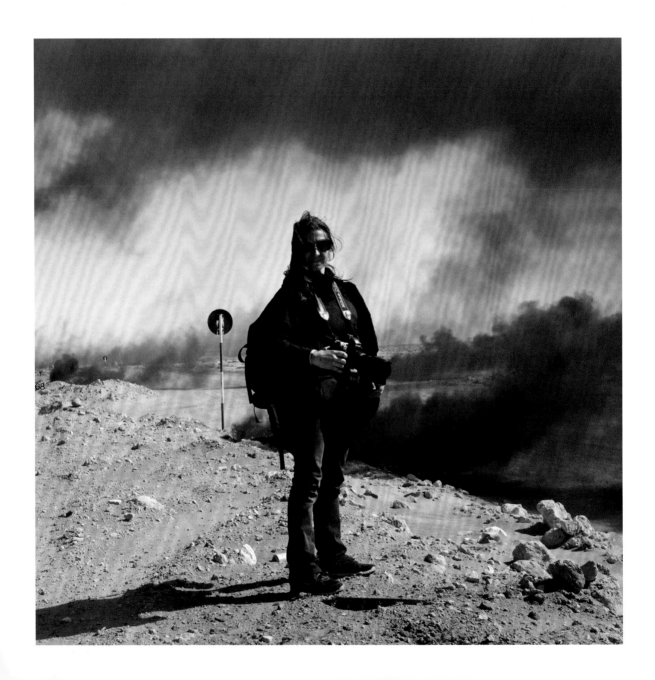

ADDARIO

THE TRUTH SEEKER

One of the most respected photojournalists working today, Lynsey Addario has photographed in many of the world's most dangerous places, from Afghanistan and Iraq to Libya, Haiti, Syria, Ukraine and the Republic of the Congo. Reporting from frontlines and covering humanitarian crises, she has been kidnapped twice but remains committed to showing the cost of war. Holding the belief that images can change the world, Addario has described what she does not as a job, but as a calling [21].

Born in Connecticut in the United States to Italian American parents, Addario began her photography career in the mid-1990s at the *Buenos Aires Herald* in Argentina, having studied international relations and Italian at the University of Wisconsin-Madison. Working for a time as a 'stringer' (a freelancer who contributes to news organizations on a per-story basis) for the Associated Press in New York, Addario travelled to Cuba where she photographed life in the island country, a place she has described as 'forbidden' for Americans [22]. She began to forge relationships with news outlets including *TIME, Newsweek, National Geographic, The New York Times* and *The New York Times Magazine* and, in the years that followed, covered all kinds of humanitarian stories involving women and the impact of war on civilians and soldiers. One of only a few photographers to have documented life under the Taliban in Afghanistan before the country was invaded by the United States and allied nations and also after the invasion, Addario has made work about maternal mortality, displaced families and children, women in combat, trans sex workers and sexualized violence as a weapon of war.

Spending her 20s and early 30s responding to major news stories, Addario, who was part of *The New York Times* team that won the Pulitzer Prize for International Reporting in 2009, decided to start a family in her late 30s. Continuing to work while she was pregnant, although not on the frontlines of conflict zones, Addario received criticism and responded by pointing out that many of the women she was spending time with were also pregnant [23]. Indeed, she has spoken about sexism in the industry and is an advocate for women working as photographers in conflict zones. 'If a woman wants to be a war photographer, she should,' she told *The New York Times*. 'It's important. Women offer a different perspective.' [24]

In 2015, Addario published *It's What I Do: A Photographer's Life of Love and War*, a memoir which touches on, among many subjects, the challenges of balancing motherhood and life as a conflict photographer. She says there have been times when being a woman photographer has been useful in gaining access, for example, to families and homes in conservative Muslim countries such as Afghanistan and Pakistan.

A photographer who is constantly searching for new ways to engage the viewer, Addario photographs stark, graphic realities that do not make easy viewing. But she looks for beauty too, her great skill lying in her ability to combine narrative with a dynamic composition to make people stop, look and think.

PHOTOGRAPH INTO THE LIGHT
TO CREATE DRAMA

An Iraqi woman in Basra is seen walking through smoke from a fire at a nearby liquid gas factory. She is searching for her husband. Several factors give the image its undeniable power. By photographing the woman from behind, getting in close and low and shooting slightly wide Addario creates the impression that we're following her. By shooting into the light, she creates a silhouette of the woman. Surrounded by light, her presence is accentuated. An anonymous figure, the woman becomes a symbol of all women who have been caught up in conflict.

Try using a similar compositional approach. Have your subject walk away from you into the light and see how creating a silhouetted figure can bring your image to life.

70

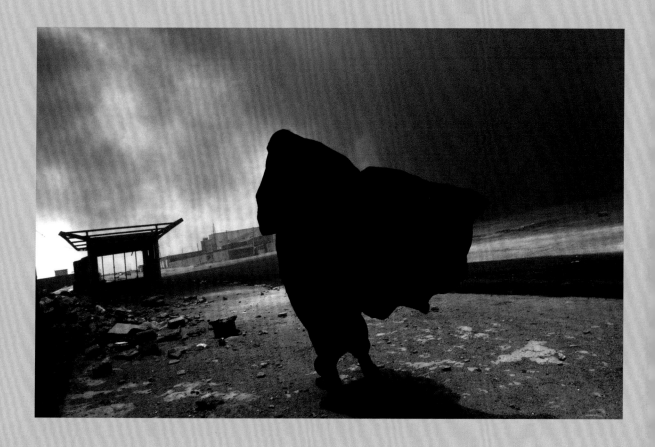

An Iraqi woman walks through a plume of smoke rising from a massive fire at a liquid gas factory as she searches for her husband in the vicinity of the fire in Basra, Iraq, Lynsey Addario, 2003

MADAME

English
1893–1975
Art
Portraiture
Still life

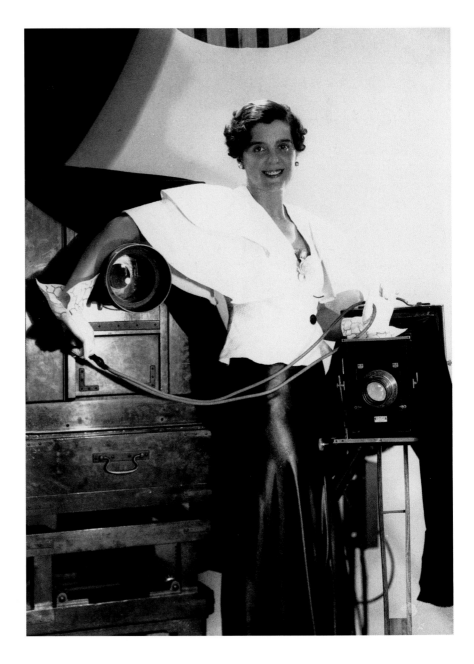

YEVONDE

THE COLOUR DEVOTEE

Madame Yevonde (born Yevonde Philone Cumbers) is best known for using colour at a time when colour photography was not taken seriously and black-and-white photography was considered to be a superior medium. She made her name as a colour pioneer in the 1930s, but her story stretches back much earlier than this.

Educated in Europe, as well as in England, Madame Yevonde joined the suffrage movement in 1910 while she was still a teenager, her indomitable temperament and strong beliefs on women's emancipation already firmly established. Interestingly, it was the suffrage movement that contributed to her interest in entering the photography profession: she saw an advertisement calling for photographers' apprentices in *The Suffragette* newspaper. As Yevonde wrote in her autobiography, she took up photography with the express intention of becoming independent, including to support herself financially. Although not an entirely unique route for a woman to have taken, it was by no means commonplace.

Successfully applying to apprentice with the eminent portrait photographer Lallie Charles in 1911, she learnt skills such as how to develop negatives and retouch prints and went on to open her own portrait studio in London three years later. It was from this time that she adopted the professional name Madame Yevonde.

Acutely aware of women's shifting aspirations, especially when it came to the way they presented themselves, Madame Yevonde developed a bold, new contemporary approach to portraiture. Her theatrical style was as confident and individual as she was: she was known to light her subjects (often society ladies) in a dramatic way, posing them against bold backdrops or using props, costumes and set pieces to create a sense of dynamism in her images. Madame Yevonde's reputation grew and she was not short of willing sitters. Her images were published in magazines such as *Tatler*. Moving her studio to a larger premises in 1921, she began to exhibit her work. Notably, that same year she achieved the accolade of becoming the first woman to address The Professional Photographers' Association to whom she presented her views on what she believed photographic portraiture by a woman could be, no doubt ruffling feathers among the mainly male audience.

Nothing, it seems, could hold her back, and creatively she went from strength to strength. But it was with the invention of the Vivex colour process that her work really took off. Colour clearly suited her innovative take on photography and larger-than-life personality. From the earliest days of the process to when it was discontinued, Madame Yevonde made colour photography her own. Her famous 'Goddesses' series (1935) saw her use the medium to impressive effect, with her sitters – dazzling socialites who emanated elegance and grace – becoming mythological characters. An innovator who also made equally inventive still-life images, Madame Yevonde was a photographer who followed her convictions, paving the way for future generations of image-makers to discover colour photography for themselves.

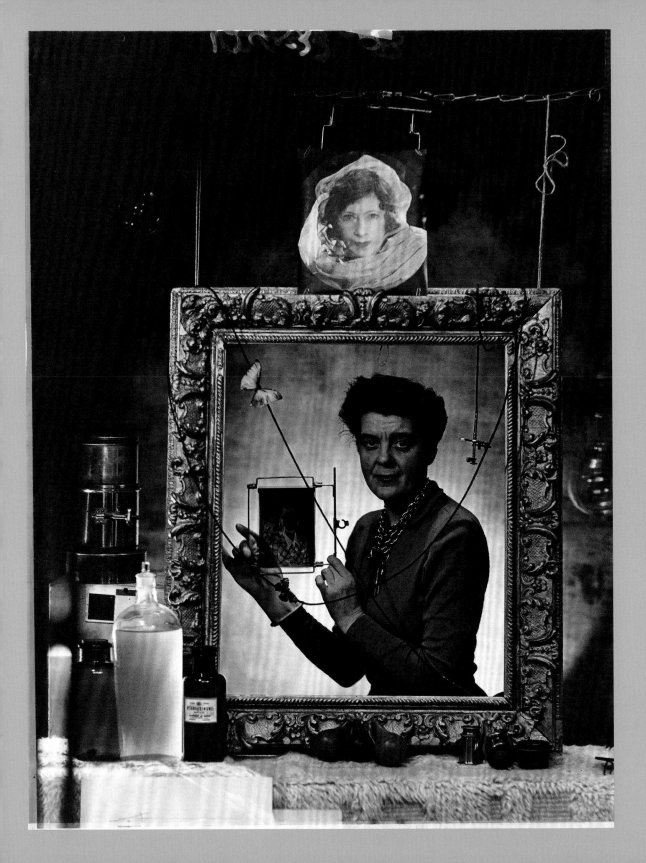

STAGE A CREATIVE SELF-PORTRAIT

In one of her final images made using the Vivex colour process, Madame Yevonde is pictured surrounded by items that paint a picture of who she is. Image-processing chemicals and a lens are carefully positioned in the foreground, creating a lively still-life tableau. There is a print from her 'Goddesses' series (featuring the Duchess of Wellington as Hecate) at the top of the image.

Create your own self-portrait by arranging objects that say something about who you are. Make the scene as colourful as you can and have a go at creating layers with props to give the illusion of depth. Think especially about how to balance different colours in your composition: try using one main colour and two complementary colours, for example.

Yevonde, Madame Yevonde, 1940

CATHARINE WEED BARNES

American
1851–1913
Architecture
Documentary
Landscape

THE CAMPAIGNER

Catharine (aka Catherine) Weed Barnes Ward was among America's earliest women photographers. She worked tirelessly to advocate for women in photo-graphy at a time when society deemed a woman's place to be in the home. A public speaker, writer and magazine editor, Weed Barnes Ward was not shy about coming forward and sharing her views. In one notable essay, 'Photography from a Woman's Standpoint' [25], she urged that women photographers be judged on their own merit, commenting that, 'Good work is good work whether it be by man or woman, and poor is poor by the same rule.' Weed Barnes Ward was referring to the submission of work for exhibitions and competitions, but her point that women photographers should be treated as men's equals was valid across the board, not least when it came to professional work. The truth was that women did not have the same opportunities to work professionally as men. But that did not put off Weed Barnes Ward. In fact, it compelled her to fight harder for women photographers to be held in the same regard as their male counterparts.

Born in Albany, New York State, Weed Barnes Ward began studying photography at the age of 35. In 1890, she started working as an editor for *American Amateur Photographer* magazine in New York, writing a column called 'Women's Work'. She was a member of several societies whose members were mainly men, including the National Photographers' Association of America. Travelling to Great Britain in 1892 to address a photography convention, Weed Barnes Ward met and married the author, photographer and publisher Henry Snowden Ward. The husband-and-wife creative partnership co-edited the photography magazine *The Photogram*, which they founded, and produced travel books illustrated with photographs.

The subject matter of Weed Barnes Ward's photographs includes landscapes and buildings of historical importance, often associated with great writers such as Charles Dickens and William Shakespeare. More record shots than art, the photographs were presumably made in this way to meet the requirements of the books she and her husband were making. The volume of material and the precision and consistency with which Weed Barnes Ward worked should be acknowledged, however. Occasionally she worked with great flair, creating staged images with a narrative bent in response to lines from poems and capturing charming scenes.

Although not as well known as her contemporaries, Frances Benjamin Johnston (p. 136) and Gertrude Käsebier, Weed Barnes Ward greatly helped advance the cause of women in photography. She paved the way for countless others to not only pursue photography as a vocation or explore its artistic possibilities but to be taken seriously for their efforts. Her work is held in the collection of the George Eastman House, International Museum of Photography, in Rochester, New York State. The Kent Archaeological Society has what is believed to be the second-largest collection of her negatives.

PLACE A FIGURE IN THE LANDSCAPE

Much of Catharine Weed Barnes Ward's work includes photographs of architecture and interiors but she also produced images where the subject is set within a wider context.

Using a wide-angle lens, create an image where the surroundings and your subject are in dialogue. Find a location, perhaps a rural setting, and position your subject within the space. If it's daytime, shoot hand-held using a low ISO. Stand back from your subject so they are small in the frame. Experiment with your aperture to vary the depth of field, keeping an eye on your exposure and adjusting your camera settings as necessary. Try using 'Aperture Priority' mode where you set the aperture and the camera controls the shutter speed. Think about how you can use foliage or other features in the scene to frame your subject.

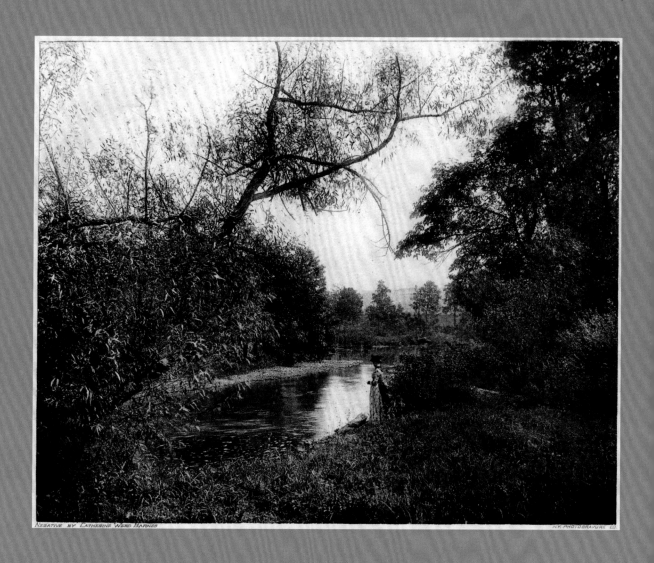

By Still Waters, Catharine
Weed Barnes Ward, 1892

JULIE

1966
British
Art
Mixed media

COCKBURN

THE STORY WEAVER

From an early age, Julie Cockburn would voraciously make and draw, cutting out her drawings and turning them into sculptures. Those 'formative years stay with you' [26], Cockburn has said and that has certainly been the case for an artist whose childhood creative endeavours not only influenced her professional trajectory, but also laid a solid foundation for her future art.

Working with found photographs and paintings, postcards, maps or indeed any object that catches her eye, Cockburn breathes life into forgotten images by embroidering and embellishing them. Scanning each photograph and initially working on the copy, Cockburn 'sketches' out an idea for how the artwork will look. Once she is happy with a design, she transfers it onto the original and begins stitching, collaging or adding other embellishments such as beads.

Growing up in London, Cockburn remembers visiting her grandmother in Hampshire at weekends. It was she who taught Cockburn to sew. Cockburn's interest in working with found images and other objects took hold when she was at college studying for a degree in sculpture. Most of the work she did involved cutting out photographs or turning photographs she had taken into sculptures – making images three-dimensional. As time went on, Cockburn began frequenting car boot sales and scouring junk shops, charity shops and online sites for images she could use. Often working with formal studio portraits from a bygone era and generic landscape images, Cockburn is drawn to the stillness and space of such images, which are at once familiar and forgettable. It is within this space that Cockburn can add her own 'magic' or some kind of narrative. The images' colours, which have the look of 1950s Technicolor, are another huge draw for the artist.

Each image has its own history, says Cockburn, whose work has everything to do with responding to, and working with, what is already in an image, whether an essence or compositional quirk. The process is surprisingly physical and can be emotionally wearing. Guided by intuition as much as her sharp eye for design, Cockburn can spend anywhere from a few days to two weeks working on a piece, depending on its complexity.

The artist, who lives and works in Suffolk, UK, has also turned her hand to screen printing, altering the appearance of a person's face by enlarging images and then screen printing colours on top, and has applied paint to photographs. Engaging with issues to do with identity, memory and photography's unique ability to freeze time, Cockburn plays with the physical nature of photographs and other found images to encourage viewers to look again at all but forgotten images. As with the best photographic artworks, there is no single way to read Cockburn's work. Rather, audiences are invited to embark on a journey into the images and back in time, and in doing so experience the images anew.

HAND-STITCH A PHOTOGRAPH

In a digital age, it can be fun to remind yourself of photography's physical properties by creating an artwork that is as much an object as it is an image. Search online or in junk shops for old photographs and make copies to practise on. Before you start working on the original photograph, add a layer of fabric to the back of it, as Julie Cockburn does, to protect it.

Once you've worked out your design, start stitching, using a fine needle to allow you to be as precise as possible. Think about which parts of the image you want to accentuate and carefully build up the stitching. Less is more, so be discerning.

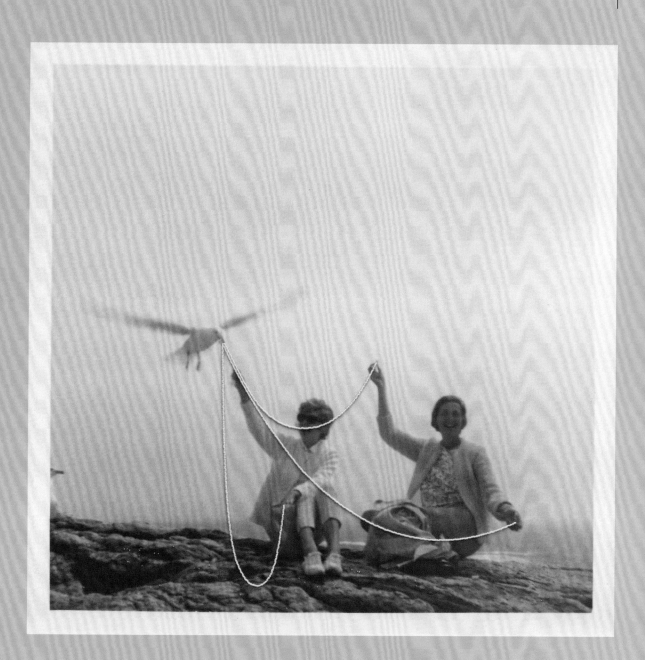

Feed the Birds (Women),
Julie Cockburn, 2019

LOLA ÁLVAREZ

Mexican
1907–1993
Architecture
Documentary
Portraiture

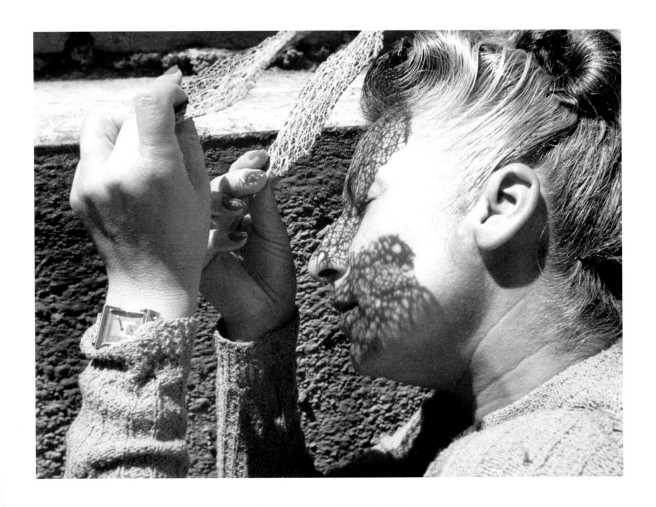

BRAVO

THE REBEL

In the past, Lola Álvarez Bravo's accomplishments have been eclipsed by her famous photographer husband, Manuel. Not anymore. Álvarez Bravo, the woman credited as one of Mexico's first female photographers, is finally receiving the recognition she deserves.

Known for her enigmatic portraits of prominent artists, writers and thinkers in her home country, including most famously Frida Kahlo, Álvarez Bravo was also a highly respected architectural photographer and worked for many years as a documentary photographer for various government agencies. It is her personal work, however, that is her most impressive. A leading figure in Mexico's burgeoning modernist movement, Álvarez Bravo took pictures for herself while on assignment. Tasked with documenting everything from life in the Mexican countryside to industrialization and urbanization, she built up a collection of personal images that capture the unique character of Mexico. Notably, she spoke of the uniqueness and intensity of the country's light, which she used to great effect in many of her images, including portraits of ordinary people going about their lives, dynamic landscapes and street scenes with a distinctly conceptual flair. She had a knack for spotting and capturing abstract form and patterns in thrilling ways, always carefully balancing light and shadow, so much so that many of her images possess an appealing sculptural quality.

Born in the small city of Lagos de Moreno in the state of Jalisco, Álvarez Bravo and her family moved to Mexico City when she was a child. Raised by relatives after she was orphaned, Álvarez Bravo married her childhood friend Manuel in 1925, from who she learnt basic photography techniques. Often assisting him in the darkroom, Álvarez Bravo also took photographs and began to develop her own style. Influential figures in Mexico's flourishing cultural scene, the couple opened a gallery where they exhibited their own and others' artwork and co-founded a film club in support of the Mexican film industry. After their separation in 1934, Álvarez Bravo continued in photography, forging a successful career for herself, not only as an in-demand photojournalist, advertising photographer and portrait photographer, but also as a curator and teacher. Joining the Liga de Escritores y Artistas Revolucionarios (LEAR: League of Revolutionary Writers and Artists), she organised an exhibition of work by women artists and accepted commissions from various publications. Her work was as varied and cutting edge as it was high in volume, and notably included avant-garde photomontages, which often addressed political issues. Running her own gallery in Mexico City from 1951 to 1958, Álvarez Bravo put on an exhibition of Kahlo's work – the only solo exhibition of the artist's work in her birth country during her lifetime.

A woman who did not just get by in the male-dominated world of photography, Álvarez Bravo thrived, remarking that as 'the only woman fooling around with a camera on the streets,' and consequently having to face down reporters who made fun of her, 'I became a fighter.' [27]

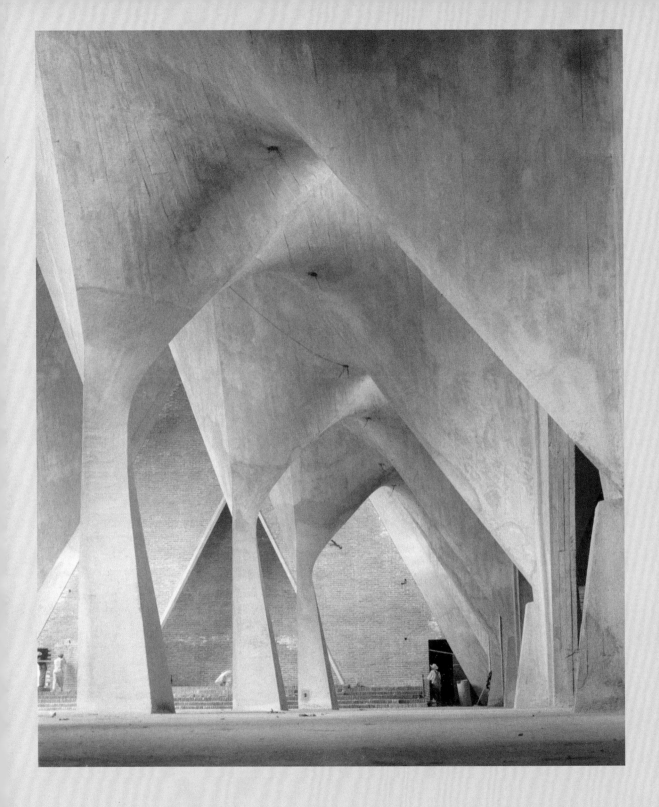

SHOOT A PIECE OF ARCHITECTURE TO DEMONSTRATE ITS VAST SCALE

It's Lola Álvarez Bravo's exquisite handling of the interplay of light, shadow and geometric forms that gives her photograph of Iglesia de la Medalla Milagrosa or Our Lady of the Miraculous Medal Church (1953–55) in Mexico City its 'wow factor'. Notice the two tiny figures towards the bottom of the frame who are dwarfed by the massive scale of the structure.

Try using a similar approach with a towering building near to you. You could photograph outside or inside (with the correct permissions in place). Shoot with your camera on a tripod, and experiment with using a wide-angle lens to capture as much of the scene as possible. Fill the frame with your subject and watch out for distortion.

Untitled, Lola Álvarez
Bravo, 1954

BERENICE

American
1898–1991
Architecture
Portraiture
Scientific

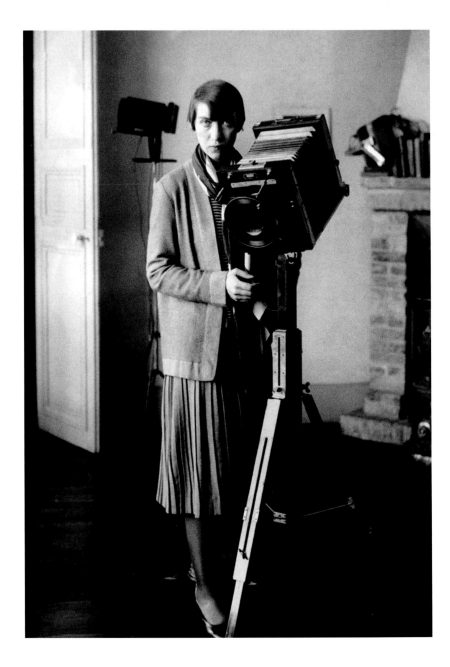

THE VISUAL SCIENTIST

Berenice Abbott mastered photographic portraiture, documentary and architectural photography, but it was the making of scientific photographs that was, she said, the most thrilling part of her long career in photography [28]. In her illustrations of scientific phenomena made in the 1940s and 1950s, Abbott made the invisible visible. Her work brought understanding and clarity to complex scientific ideas. Developing approaches that enabled her to record scientific happenings, Abbott demonstrated the way glass splits light into different wavelengths, how a ball rolls across a table and the movement of a swinging pendulum. As aesthetically sophisticated and innovative as they are informative, Abbott's scientific photographic illustrations are not as far removed from her previous work as we might assume. The striking lines and refined handling of light and dark, tenets of modernist photography, are reminiscent of the exquisitely composed, dynamic New York City images for which Abbott is best known. With their meticulous rendering of form, Abbott's scientific studies are clearly the work of a photographer with an inquisitive mind and an appetite for pushing the limits of photography.

By her own admission, Abbott fell into photography. Born in Ohio, she had wanted to be a journalist, but a move to New York to study painting and sculpture in 1918 set her on a different path. Moving in avant-garde circles, Abbott travelled to Paris in 1921, as many other young artists were doing, where she set up a life for herself, pursuing an interest in sculpture. From 1923, she worked for the artist Man Ray as his darkroom assistant, opening her own photography studio in 1926. During her time in the French capital, Abbott perfected the art of portraiture, her subjects ranging from dazzling socialites to bohemian artists and literary luminaries.

On returning to New York in 1929, Abbott embarked on an epic project to document the changing face of the city. While living in Paris, she had come across the work of the pioneering documentary photographer Eugène Atget. At the time, Atget's work chronicling the streets of Paris was little known outside the French capital but with Abbott's help that changed. Abbott, who had acquired some of Atget's archive after his death, promoted his work, publishing and later bequeathing it to the Museum of Modern Art. Clearly inspired by Atget's images of Paris, Abbott recorded the transformations taking place as New York hurtled towards the great new dawn of modernization. With financial support and other resources in place, Abbott was able to produce a wide-ranging photographic survey of New York comprising some 300 photographs which skilfully juxtapose the old and the new. Working as a teacher of photography at the New School for Social Research (now the New School) in New York, Abbott produced photographs for the Massachusetts Institute of Technology (MIT) and was committed to using photography as a tool to demystify science. She not only created images that functioned as vehicles for knowledge, but that were also beautiful. Bringing the principles of science to life, Abbott's photographs celebrate the fundamentals of photography itself – light, motion and time.

MANIPULATE LIGHT

It's possible to create your own conceptual images using simple, everyday items. Try photographing refracted light through a transparent household object such as a wine glass. Set up your DSLR camera minus a lens on a tripod in a dark room. Fix your light source (an LED torch works well) to a stand and position it two metres from your camera. Tape a piece of cardboard with a small hole in it to the front of your light source to create a fine beam of light.

Attach the wine glass to another stand or holder and position it in front of your camera. Check that the light source is at a right angle to the camera and that the beam of light directly faces and enters the glass (which functions as the camera lens). Make an exposure! Use coloured gels to create colourful patterns.

Beams of Light Through Glass,
Berenice Abbott, c. 1940–1960

CONSUELO

American
1894–1978
Art
Documentary
Portraiture

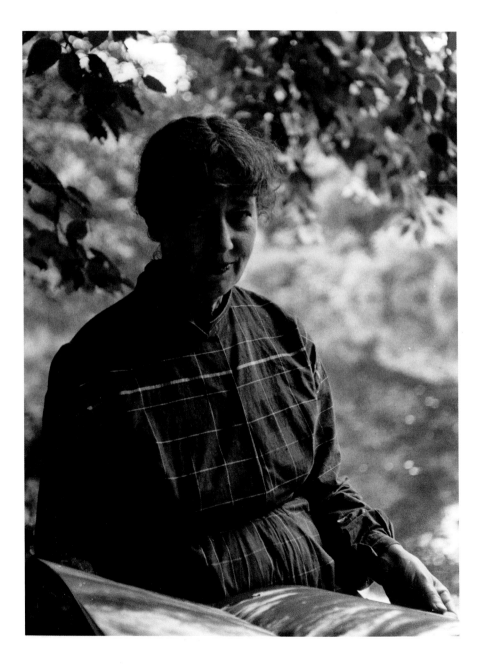

KANAGA

THE LIGHT SCULPTOR

Unlike her contemporaries, the photographers Imogen Cunningham, Dorothea Lange and Edward Weston, American-born Consuelo Kanaga is not well known in histories of photography. Nonetheless, her contribution to photography – in particular, the compassion-filled images she took of African-American people from the 1930s onwards – deserves to be better known.

Born in Astoria, Oregon, Kanaga, who was of Swiss heritage, began her career in 1915 as a reporter for the *San Francisco Chronicle*. After learning how to process negatives from the newspaper's photographers, she became a staff photographer. During this time, she got to know members of the local photography community, including Lange, Weston and Cunningham. The photographers belonged to the prestigious Group f/64, a collective whose members rejected pictorialism's soft-focus approach and instead made photographs that were carefully framed and sharply focused. Although not an official member, Kanaga exhibited work with the group.

Moving to New York in the early 1920s, Kanaga began working for the Hearst-owned daily newspaper *New York American*. She met Alfred Stieglitz, whose deeply held beliefs in the artistic possibilities of photography must have left an impression on the young photographer. Indeed, Kanaga developed a style that was not only concerned with documenting the world around her, but sought to bring out the emotions of her subjects, their humanity. Her greatest images are those that give a sense of the person she is photographing and their experiences. Often tightly framed and so avoiding wider context, Kanaga's images, considered and thought-provoking, bring us close to her subjects. In their eyes we glimpse endurance, hope and pride. The naturalness and sensitivity with which she portrays her subjects sets her work apart. Edward Steichen noticed this and included Kanaga's work in his landmark exhibition 'The Family of Man' in 1955.

Learning about the African-American fight against racism, Kanaga, from the early 1930s into the 1960s, dedicated much of her time to photographing and building meaningful relationships with her subjects, who ranged from ordinary folk to artists and poets. She pictured them in a positive way at a time when negative stereotyping of Black people was widespread. In addition to her portraits, Kanaga made poetic still-life images, often of flowers and plants, striking architectural images and beautifully abstract photographs of nature and rural scenes. The social activist also turned her lens on the civil rights movements of the 1960s.

Guided by a deep commitment to social justice, Kanaga said it was the 'simple things' that fascinated her and that she wanted to show in her photographs. In a short but illuminating piece of text, Kanaga expresses her feelings on what photography means to her, writing: 'Stieglitz always said, "What have you got to say?" I think in a few small cases I've said a few things, expressed how I felt … If I could make one true, quiet photograph, I would much prefer it to having a lot of answers.' [29]

CREATE A TIGHTLY CROPPED PORTRAIT WITH STRONG CONTRAST

One way to make an impact with a portrait is to include the person's surroundings. This tells the viewer something about that person. An equally effective approach is to remove the person's surroundings entirely by coming in close, as Consuelo Kanaga did. She would often create portraits with strong contrast and a tight crop to create impact.

Shoot on a sunny day when the light is naturally contrasty. Using a focal-length range of between 85mm and 110mm if you have a zoom lens or working with an 85mm prime lens, position your subject against as plain a background as possible. Use natural daylight to light your subject and a reflector to bounce light onto their face and body. Pay particular attention to where light and shadow intersect. Have your subject turn slightly away from the camera to add interest.

School Girl, St Croix,
Consuelo Kanaga, 1963

INGRID

British
Born 1953
Art
Landscape
Mixed media

POLLARD

THE LANDSCAPE EXPLORER

Ingrid Pollard's multi-layered, wide-ranging work is neither easy to navigate nor define but that is a huge part of its appeal. For 40 years, the Guyanese-born, London-raised artist, photographer and researcher has been making work that considers many distinct but closely linked ideas or issues, including the social constructs of Englishness, race, the notion of home and belonging or 'being', community, place, encounter, national identity or nationhood, colonial histories, what is unseen or hidden and 'unhidden' and more, as realized through landscape. Black people feature often, but the 2022 Turner Prize nominee's work has more to do with Britishness than race, she says [30], although the latter is an important element.

Pollard, who has a background in film, video and performance, as well as photography, is always 'in' her work, the artist has said, because it is she who is expressing something about a landscape, a person or an issue [31]. Comprising photography, including hand-tinted photographs, and text, her work is also about photography as a medium, its history, methods and materiality. Latterly, Pollard has turned to sculpture, intrigued by its links to photography, and used film stills, sound and installation in the exhibition, 'Carbon Slowing Turning' (2022).

Born in Georgetown, Guyana, Pollard moved to London with her sister when she was about four years old to join her parents. London was her home for many years and she presently lives in Northumberland. Pollard remembers her father lending her a camera for a school geography project and recalls looking at family photo albums he had made for her mother. As she grew into adulthood, Pollard moved in 'arty' circles where cameras and photography were often around. She borrowed an enlarger and printed her own photographs and went on holidays to the Lake District with friends, which provided ample opportunities for photography. Indeed, one of the first bodies of work Pollard made on race and landscape – 'Pastoral Interlude' (1988) – came from those trips and experiences. Featuring hand-tinted former holiday snaps of Black figures in a 'traditional', 'idyllic' English landscape, alongside fragments of text, the work draws attention to, and interrogates, the complexities of the British countryside by raising questions about the formation of boundaries and ownership, the privatization and industrialization of the landscape, hidden rural histories and links to a colonial past, as well as the construction of the romantic English countryside idyll. The work is now part of the national collection at the Victoria and Albert Museum (V&A) in London.

Pollard joined a feminist photography and screen-printing collective in East London in the early 1980s and became involved with grassroots movements concerned with issues around race, gender and sexuality. She went on to become a founding member of Autograph ABP (formerly known as the Association of Black Photographers) in 1988. Studying at the London College of Printing and the University of Derby, Pollard developed a practice that was 'aligned with the politics of race and feminism' [32] and has made many bodies of work including 'The Cost of the English Landscape' (1989), 'Seaside Series' (1989) and 'The Valentine Days' (2017).

HAND-TINT A PHOTOGRAPH

Images have been tinted since the beginnings
of photography. Colour tints were applied using
small paintbrushes and soft pencils were among the
media used. If you have a box of old black-and-white
family photographs, try hand-colouring scanned
copies or convert your colour photographs to black
and white and work on those instead. You can buy
specialist dyes or use coloured pencils if you are
working on a matt surface.

Use a photograph with lots of light areas. Gently
apply colour to a few select areas to accentuate key
parts of the image, such as the hair, eyes, cheeks
and accessories, or areas of interest such as trees
or flowers. Be mindful not to overdo the effect. Use
a light touch and slowly build up layers of colour.

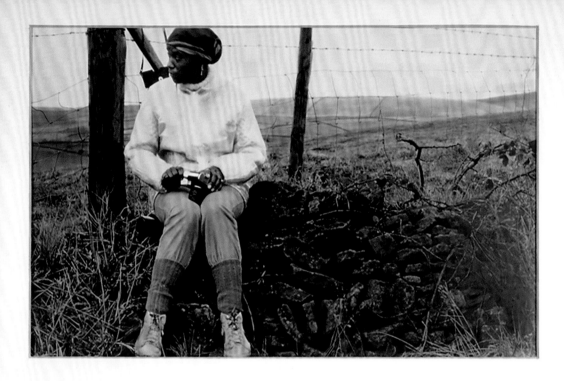

"pastoral interlude"
... it's as if the Black experience is only lived within an urban environment.
I thought I liked the Lake District; where I wandered lonely as a Black face in
a sea of white. A visit to the countryside is always accompanied by a feeling
of unease; dread ...

Pastoral Interlude,
Ingrid Pollard, 1988

ANNE WARDROPE

American
1869–1950
Landscape
Nude
Self-portraiture

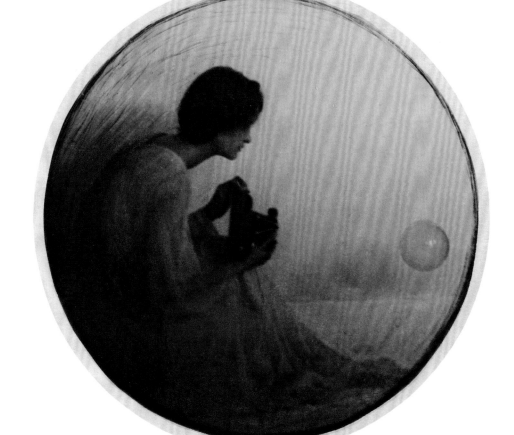

THE WILD SPIRIT

An air of mystery surrounds Anne Wardrope Brigman and her surprisingly forward-thinking photographs of female nudes in the landscape. The daughter of Christian missionaries, Brigman was born on the island of O'ahu, Hawaii, and raised in the Nu'uanu Valley, north of Honolulu. Her childhood was filled with native myths and stories of multiple gods, and she grew up surrounded by verdant mountains and lush vegetation. So began her lifelong affinity with the natural world.

Moving as a young adult to Los Gatos, California, with her family, Brigman immersed herself in the Berkeley and Oakland bohemian cultural scene. Working for a time as a painter, Brigman, who had an adventurous spirit, turned her hand to photography in her early 30s. Like her female contemporaries who dabbled in photography, she initially used a hand-held camera to take pictures of women and children in idyllic settings but went on to use a 4×5 camera to capture her iconic nude photographs.

A keen mountaineer, Brigman was drawn to the mountains of Sierra Nevada, a place not considered appropriate for women. It was there, amid the craggy terrain and expansive vistas, that Brigman cast off the shackles of her gender and made photographs by herself and with friends. Such bold actions were truly groundbreaking – indeed, Brigman has been credited as the first woman in America to photograph her own nude body.

Embracing pictorialism, an approach to photography that favoured expression and beauty, Brigman manipulated her negatives and prints. By using graphite and scratching at the surface of her images, she created atmospheric and dreamlike images of the figure in the landscape. The resulting photographic prints were whimsical and idealistic, but also alluded to nature's darker side. They were unlike anything else being created at that time.

Heavily ensconced in the Californian Bay Area photographic community, Brigman was well respected by many of her peers. In particular, her work was highly regarded by the photographic luminary and founder of the Photo-Secession, Alfred Stieglitz. He invited Brigman to become a member of the group, which promoted photography as art. The pair exchanged letters over many years, with Stieglitz publishing Brigman's images in the prestigious *Camera Work* magazine and championing her work throughout the East Coast where he was based.

Unmatched in her radical approach to photography, Brigman was a pioneer in the sense that she promoted ideas of female empowerment long before feminist art was established. As scholar Kathleen Pyne has argued, Brigman was driven to use her photography to call for 'social, political, and economic liberation' for women [33], but there's also an unmistakable sense from Brigman's work that she is searching for something or answering some kind of spiritual calling. Whatever her rationale, Brigman resolutely trod her own path in photography.

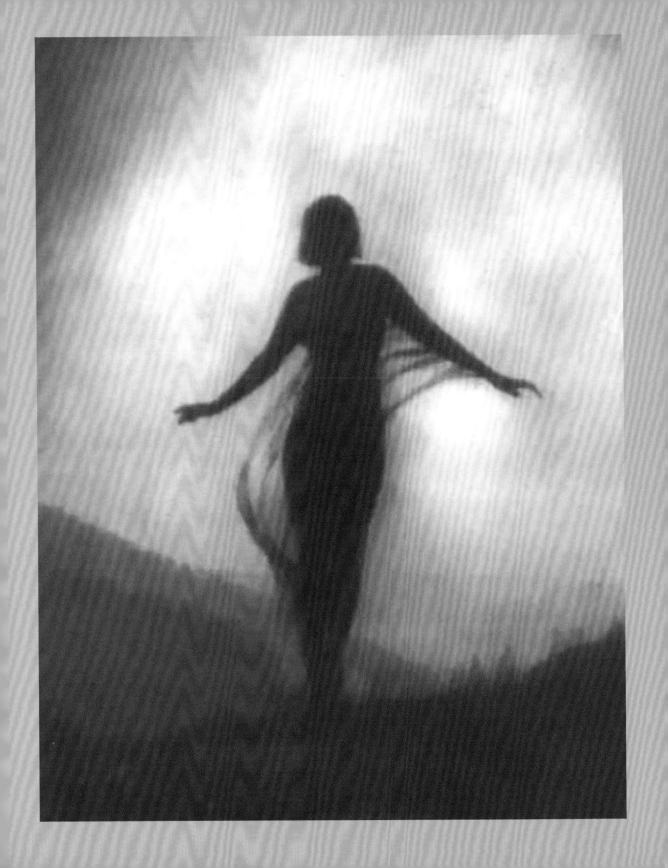

PHOTOGRAPH A FIGURE UP CLOSE IN THE LANDSCAPE

The technique of situating a figure in the landscape that Brigman made her own is one that can be employed in various creative ways. Choose a landscape that you find inspiring and get to know it by spending time there in all kinds of light and weather. Start photographing and study the images to see what makes a strong composition. Once you've begun to understand your chosen landscape, bring in your model.

Think carefully about how that person 'sits' in their surroundings, paying particular attention to the relationship of subject to background as Brigman did: her figures seem to emanate from, or disappear into, their surroundings. Encourage your model to try different poses. Keep an eye on your focus and pay attention to the interplay between light, figure and landscape. Try photographing into the light to create a silhouette of your model.

The Breeze, Anne Wardrope Brigman, c. 1910

VERA

German
Born 1960
Architecture
Art
Landscape

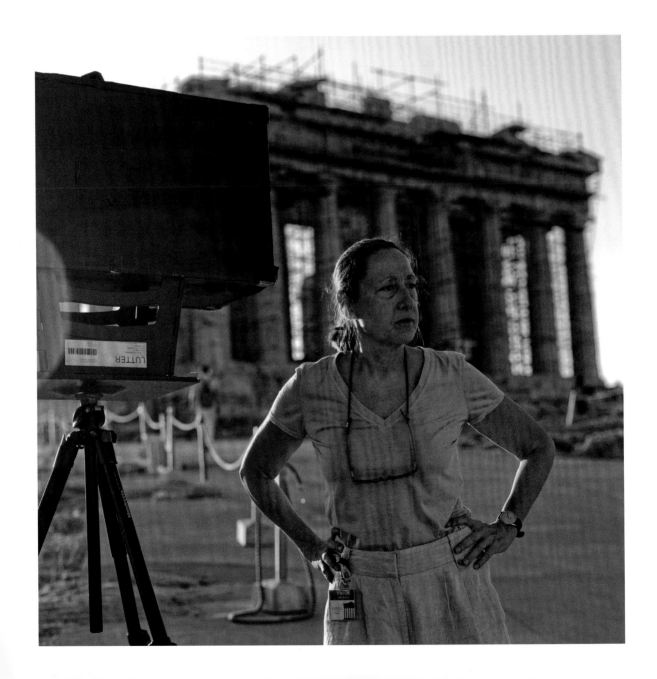

LUTTER

THE CAMERA-OBSCURA MAESTRO

A glance at the work of renowned camera-obscura artist Vera Lutter and you are transported to another universe. What you are seeing when you look at one of her ghostly artworks is an inverted image where brightness becomes dark and dark areas are rendered light. For decades, Lutter, who was born in Kaiserslautern, Germany, has been producing her otherworldly images using the camera-obscura technique, the roots of which date back to antiquity. She discovered the process in the 1990s while living and studying in New York. Intrigued by the city's architecture and the way the light fell on the buildings around her, Lutter, who had originally trained as a sculptor in Munich and made work as a ceramicist, began experimenting, transforming her apartment into a camera obscura.

Latin for 'dark chamber', a camera obscura is a darkened room with a tiny opening in one wall through which light travels, creating an inverted image that is projected onto the opposite wall. It can also be a box or, indeed, any kind of darkened container or shack. In her long career, Lutter has used objects of varying sizes and forms as her camera obscura, including a shipping container, cabin, wooden shed and a travel trunk.

From early on in her experiments with the ancient technology, Lutter projected images of the outside world onto large pieces of light-sensitive paper. Doing so meant she could preserve the immediacy of the image-making process – an integral part of the way she chooses to work. She then develops the exposed paper in the darkroom in her studio. Each print – a negative image in varying shades of grey, black and white – is unique.

Over the years, Lutter has made numerous large-scale camera-obscura images of various urban, industrial and historic landscapes and monuments in New York, London, Frankfurt and Venice, among other places. Her most famous subjects include Battersea Power Station, Times Square, the iconic Pepsi-Cola sign in Queens, New York, the Effelsberg radio telescope in Germany and the sculpture garden at the Museum of Modern Art (MoMA) in New York. She has also used the process to picture construction sites, museums, nature and transportation infrastructure such as airports.

The work is labour-intensive and fraught with uncertainty, despite the intricate planning, development and research that is required, which can take many months. The length of each exposure varies too, from several hours to weeks or even months.

Less interested in creating 'straightforward documents' [34], Lutter is more concerned with making images that 'represent the uncanny' or that trigger feelings of uncertainty among viewers. While photography is often associated with freezing a moment in time, Lutter's work is akin to slowing down time or recording the process of time unfolding. Otherworldly and mysterious, her work invites us not only to contemplate the scene before our eyes, but to think about the image-making process itself.

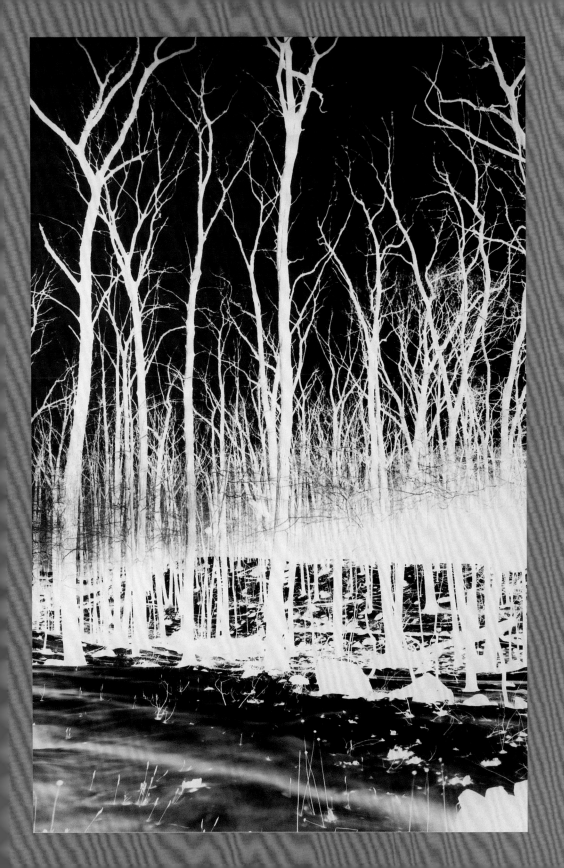

MAKE YOUR OWN CAMERA-OBSCURA IMAGE

To create your own 'pinhole' photography image,
you will need a light-proof box with a tiny hole in one
side and some photo paper. Make a box from black
card and add a pinhole. Lots of online resources
explain how to do this. In darkness, insert your piece
of photo paper. Make sure the entire unit is sealed
before turning the light back on.

Take your camera outside to make your photograph.
On a sunny day, try an exposure of 30 seconds, but
adjust the length of exposure as required. Aim for
still subjects that have a good amount of contrast.
Once you have exposed your image, keep it in the
dark until you're ready to develop it, which you can
do at home with the right equipment.

Cold Spring, XIII: February 25, 2013,
Vera Lutter, 2013

JULIA MARGARET

British
1815–1879
Art
Portraiture

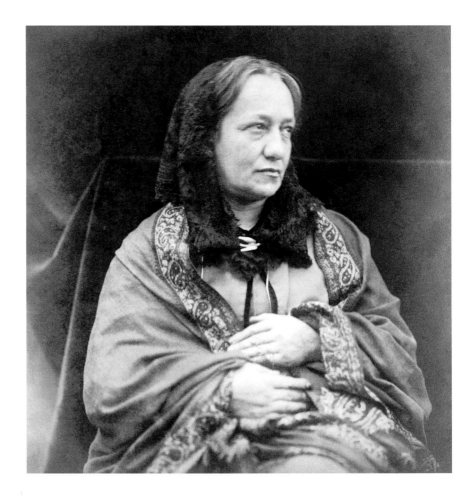

CAMERON

THE ROMANTIC

Julia Margaret Cameron, whose name is synonymous with early portrait photography, had a knack of capturing something indefinable in her images, an essence of something or someone. Cameron was 48 years old when she began making pictures, having been given a camera by her daughter and son-in-law. Living on the Isle of Wight at the time, Cameron threw herself into her new pursuit, famously converting the family coal shed into a darkroom and the glasshouse into a studio.

Cameron was already familiar with photography, having been shown examples of photographic images or 'Talbotypes' (named after their creator, William Henry Fox Talbot) as early as 1841 by her close friend, the esteemed chemist and astronomer, Sir John Herschel. Ever the experimenter, she also made albums and constructed an artwork by combining a print she had made from a negative by the acclaimed Swedish photographer Oscar Gustave Rejlander and a photogram (a cameraless technique) frame of ferns. But it is for her mesmerising, evocative portraits, completely unlike anything else at the time, that she is best known.

Moving in literary and artistic circles, Cameron frequently photographed her close friends and family, although she also made portraits of household staff. Her sitters included well-known figures of the day, such as the poet Alfred, Lord Tennyson and the naturalist Charles Darwin. Praised for her unswerving belief that photography was an art form, while also copyrighting, exhibiting, publishing and marketing her photographs, Cameron forged a pathway in photography that was all her own.

Often staging biblical and allegorical scenes, which involved casting her subjects as characters, she would frequently fill the frame with her subject and experiment with soft focus, creating emotionally charged portraits that went against convention precisely because they were not aesthetically 'perfect'. Using wet-collodion glass negatives and producing albumen prints from them, she embraced 'mistakes' such as streaks and smears that occurred during the process. To make a photographic portrait using the wet-collodion process was challenging, not only because it required the sitter to remain still for several minutes while the exposure was made (inviting movement blur), but because it was easy for fingerprints or other marks to creep in as the chemical-coated glass plates were handled. Cameron was also not averse to scratching on her negatives to change or improve an image and would make prints from those that were damaged. Although she received criticism for working in what some regarded to be an unconventional way, scholars have speculated that such 'imperfections' add to, rather than detract from, her photographic portraits, making the hand of the artist clear for all to see.

For a woman in Victorian Britain to achieve such acclaim and success in photography was highly unusual. From atmospheric narrative and allegorical tableaux that draw the viewer into dreamy worlds, to penetrating portraits, Cameron's photographic portraiture is as startling today as it would have been when she made her photographs.

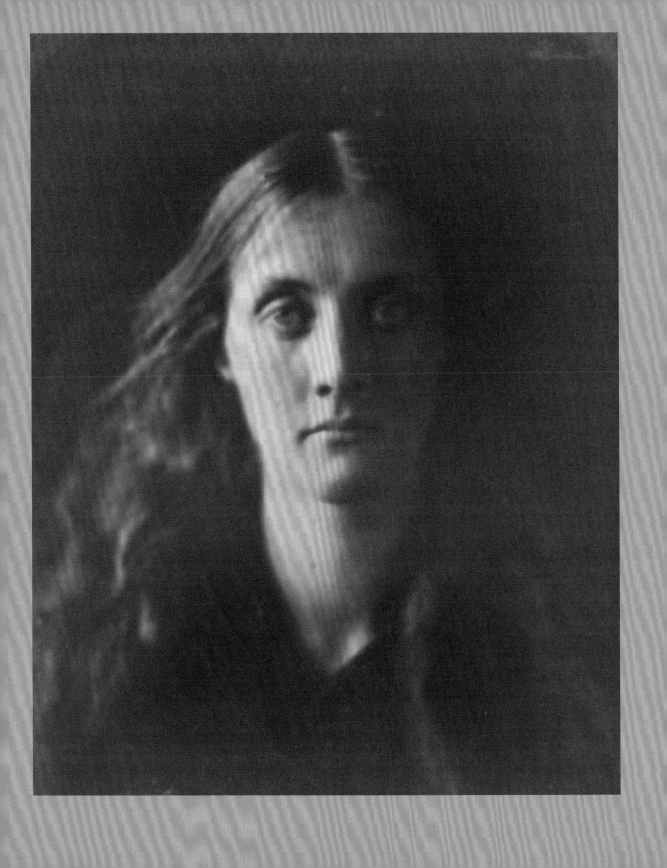

USE A LONG EXPOSURE TO CREATE AN EVOCATIVE PORTRAIT

While you may not be using the wet-collodion process, it is possible to create engaging portraits akin to those Julia Margaret Cameron made by following a few straightforward tips.

Close the curtains in the room you're using to make your portrait. Seat your subject in a chair and place your camera on a tripod in front of your subject. Perhaps use a dark backdrop – a piece of card or fabric will do. Position a simple light, or even a lamp, to the side of your model (on a side table, for instance), at face height. Use a white or silver reflector on the other side to bounce light back onto your subject. Try different shutter speeds to vary the look of the image.

111

Julia Jackson Duckworth (1846–1895),
Julia Margaret Cameron, 1867

ANJA

German
1965–2014
Documentary
Photojournalism

NIEDRINGHAUS

THE INTREPID HUMANITARIAN

On 4 April 2014, Anja Niedringhaus was shot dead in Khost province, eastern Afghanistan. She was 48 years old. The veteran conflict photographer was sitting in a car with her Associated Press colleague Kathy Gannon when an Afghan gunman opened fire on their vehicle. Niedringhaus was killed instantly, while Gannon survived the attack. The pair, the first foreign journalists to embed with the Afghan National Army [35], were due to cover the presidential election the following day. Both had spent years in Afghanistan reporting on the experiences of people living there.

Committed, intrepid and compassionate, Niedringhaus was not your average photographer of war (she apparently disliked the term 'war photographer'). Always seeking to go beyond images of fighting and bloodshed, she produced photographs that got under the skin of a place. The German photographer, who had reported from major conflict zones, including Sarajevo, Kuwait, Iraq, Libya, Gaza and the West Bank, in her decades-long career, made it her mission to use her camera to show the impact of events on ordinary people. She was committed to telling people's stories.

Niedringhaus 'felt a sense of duty to document it all,' said gallery owner Dr Silke von Berswordt-Wallrabe three years after Niedringhaus' death [36]. It was her ability to show the individual experience that made her photographs so special, she explained. Niedringhaus' astute and sensitive homing in on the minutiae of daily life is evident in her moving images of children larking around in rubble or playing football, a quiet moment of reflection or a brief interaction. She had a knack of capturing flickers of emotion from joy to despair and everything in between. In her nuanced and affecting images, there's a sense that war is never far away, but in that moment it is a distant hum. The human experience is what matters.

Born in Höxter, Germany, Niedringhaus began working as a freelance photographer while she was at school. Having photographed the fall of the Berlin Wall in 1989, she joined the European Pressphoto Agency in Frankfurt the following year and went on to become the agency's chief photographer, reporting for a decade in former Yugoslavia. Niedringhaus joined the Associated Press in 2002, working across the Middle East and in Afghanistan and Pakistan. A member of the AP team (and the only woman) that won the 2005 Pulitzer Prize for Breaking News Photography for coverage of Iraq, Niedringhaus also covered nine Olympic Games and other international sports events.

A leader in her field, Niedringhaus was among 'the first generation of women ... who strode into the profession like she belonged,' said photographer and writer Kael Alford [37]. She has inspired countless others too, including Adriane Ohanesian who won the 2016 IWMF Anja Niedringhaus Courage in Photojournalism Award, which was founded after Niedringhaus' death. In 2017, Ohanesian told *TIME* magazine: 'She encouraged me as a woman, [to know that] you can go into any situation and come out with strong meaningful work, just like anyone else.' [38]

INCLUDE A POINT OF INTEREST TO DRAW THE EYE

Anja Niedringhaus had an eye for spotting meaningful, intimate moments in the chaos of conflict. Compositionally, her images were always impeccably conceived and precisely executed – testimony to her immense skill as a photographer.

Quite often, Niedringhaus placed her main subject in a corner or on one side of the frame to transport the viewer into and around an image. Working in this way, she created a sense of momentum, with the main subject also serving as a kind of anchor or pause point. The technique of drawing the eye into a picture that Niedringhaus used so effectively can be applied to countless subjects and settings. When composing an image, decide what your subject is and make that the focus of your picture. Everything else riffs off that.

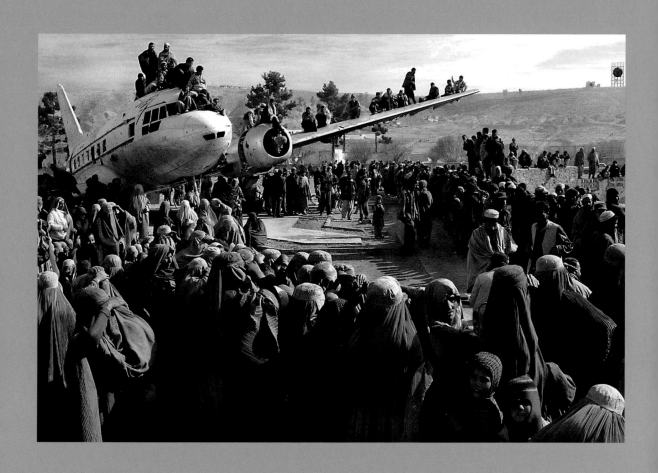

Afghan people gather around a destroyed passenger plane as they wait for humanitarian aid to be delivered near Kabul's stadium, Kabul, Afghanistan, Anja Niedringhaus, 2002

LEE MILLER

American
1907–1977
Art
Photojournalism
Portraiture

THE SURREALIST

Lee Miller experienced being on both sides of the camera – first as a model and a muse and then as an accomplished photographer who would become a celebrated surrealist artist. Photographed in the late 1920s for *American Vogue*, Miller had an artistic eye, having studied lighting, costume and design a few years earlier in Paris. Encouraged to pursue photography by the photographer Edward Steichen, Miller moved to the French capital from New York City in 1929 and became involved with the surrealists, including the artist Man Ray who was her tutor, but also her lover and collaborator. For a while, the pair made work together, famously in their joint rediscovery of solarization, a technique with its roots in the 19th century, which involves exposing a developing negative to light, causing areas of the image to tonally reverse.

Miller was born in Poughkeepsie, New York. A restless soul who constantly sought to reinvent herself, she set up her own successful photography studios in Paris and later New York, before marrying the Egyptian businessman Aziz Eloui Bey and moving with him to Cairo. She continued to make work in Egypt, often creating photographs with a surreal edge, but eventually outgrew her life there. Upon meeting the English surrealist painter Roland Penrose, Miller moved with him to London on the eve of World War II, and later to Sussex where they set up home together. During the early years of the war, Miller photographed the Blitz in London before gaining accreditation and being sent to Europe on assignment by *British Vogue*. Miller was famously among the first photographers to enter Germany as the war ended, one of only four women photographers to officially travel with the US army. As a war correspondent, Miller accompanied allied forces during the liberation of Buchenwald and Dachau concentration camps, covered the Battle of Saint-Malo (she was said to be the only journalist present in the early days of the siege) and photographed inside Hitler's abandoned apartment in Munich. A photograph taken by her colleague David E. Scherman of Miller in Hitler's bathtub is one of the most iconic images of the 20th century. Unique, surprising, even ghoulish, the photograph reveals much about Miller's audacious personality, which propelled her to take the photographs she did, the best of which are witty, insightful, frank and at times off-kilter, startling and strange. Miller had an eye for the surreal, evident in the dreamlike portraits and nude studies she made in Paris, but also the street photographs she took in the French capital and her Egypt photographs, of which this image (pictured) is one of the most striking. The oval opening, akin to an eye – a surrealist symbol/motif – perfectly frames the motley legs. Our attention is brilliantly directed to the legs by the shadow that seems to be closing in on the figures, and there is a sense that we, the viewers, are spies or voyeurs. The photograph is a wonderful mix of humour and strangeness.

Miller led such a multifarious life that there was always a danger that the stories might overshadow her work. Fortunately, thanks largely to the efforts of her son Antony Penrose, Miller's legacy as one of the 20th century's most fascinating and iconic artists has been preserved.

PHOTOGRAPH THE SURREAL IN THE EVERYDAY

Miller never passed up an opportunity to create an image that presented more questions than answers. Homing in on details, she sometimes tilted her camera, making the image less easy to decipher. She also used space in her images to make her subjects stand out in the frame.

Go out with your camera and take a moment to take in your surroundings. Does anything leap out at you as unusual? After spending time 'getting your eye in', start photographing, picking out unusual architectural details or framing your image to show parts of passers-by. In the UK it's not against the law to photograph in public spaces, but remember to respect others' personal space.

Untitled [Legs, Mafy Miller, thought to be Dimitri Papadimos, George Hoyningen-Heuné and Roland Penrose], *Gebel Mawta, Siwa, Egypt*, Lee Miller, 1939

PAZ

Chilean
Born 1944
Documentary
Photojournalism
Portraiture

ERRÁZURIZ

THE DICTATORSHIP DEFIER

To make photographs when doing so will endanger your life requires an almost unimaginable amount of courage. Paz Errázuriz did just that when she started recording what was happening around her during the Pinochet regime. For the Chilean photographer, it was a matter of necessity, a moral obligation. Photography for Errázuriz would quickly become not only an act of personal expression, but of political resistance, a means to focus attention on those who had been pushed to the fringes of society.

Errázuriz was working as a primary school teacher and teaching herself photography on the side when the dictatorship took hold. It was 1973. General Augusto Pinochet had seized power in a military coup, marking the beginning of 17 years of oppressive rule. Unable to continue in her job, Errázuriz made the bold decision to become a freelance photographer. It was a dangerous move, not least because photography was seen as an act of defiance by the state. To photograph in marginalized communities, especially as a woman (women's civil liberties were heavily curtailed during the regime), was even riskier.

Errázuriz and a group of like-minded individuals began working as photojournalists on the streets of Santiago. At the same time, Errázuriz began to make photo essays on subjects that interested her – stories that often linked back to the central theme of identity. There was a need to use metaphors, Errázuriz has said, to be cautious and clever about how and when to photograph. Her early work included images of rough sleepers and, over the coming years, Errázuriz photographed psychiatric patients, blind people, prostitutes, transvestites, ageing bodies, circus performers and many other people whom society had deemed worthless. Women from all walks of life were also her subject.

Ever curious and compassionate, she would take time to get to know and build trust with those in front of her lens, working sensitively and respectfully to portray her subjects with dignity. Among her most celebrated bodies of work is 'Adam's Apple' (1982–1987) featuring intimate and tender portraits of cross-dressing and transgender sex workers. Immersing herself in this community, Errázuriz documented the everyday lives of Pilar, Mercedes and Evelyn, often utilizing available light, which lends the images a beautiful naturalistic quality. Choosing not to pose her subjects, but committed to establishing a dialogue with them, Errázuriz has spoken about the need to show people what they don't see, to 'make people learn how to look' [39]. Errázuriz's images possess the kind of honesty only possible when a person allows the photographer into their world. Each photograph is also, for Errázuriz, a reflection, a self-portrait of sorts [40].

Despite the ever-present threats to her safety and wellbeing, Errázuriz defied a brutal dictatorship to create many powerful and deeply affecting images and continued to make important work in the years after the regime ended. The work she made so fearlessly resonates as much today as it did then.

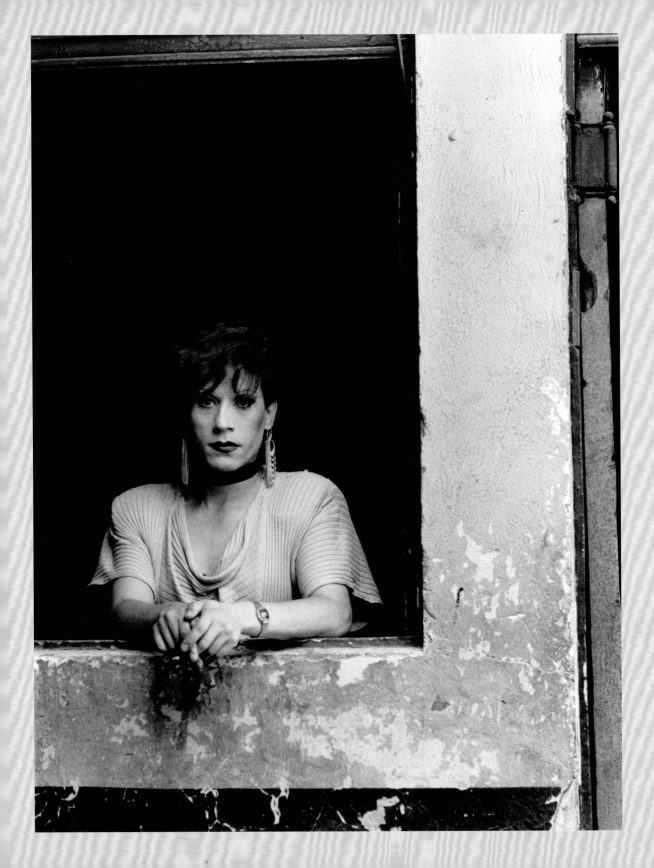

USE AVAILABLE LIGHT TO CRAFT INTIMATE BLACK-AND-WHITE PORTRAITS

Shooting on film in a pre-digital photography era, Paz Errázuriz knew how to use black-and-white photography to create images that precisely conveyed the mood and feel she wanted. Today, as then, this involves noticing how light hits the face and body and understanding how it can be moulded.

Taking every opportunity to photograph people, pay attention to how different colours translate to black and white. An 85mm prime lens is a versatile and flattering portrait lens, but a 50mm lens or a 135mm lens will also give good results. Go for a wider lens if you want to show more of the person's surroundings. Position your subject by a window and try using the frame as a creative device within the composition.

Evelyn, Paz Errázuriz, 1982

SALLY

American
Born 1951
Art
Landscape
Portraiture

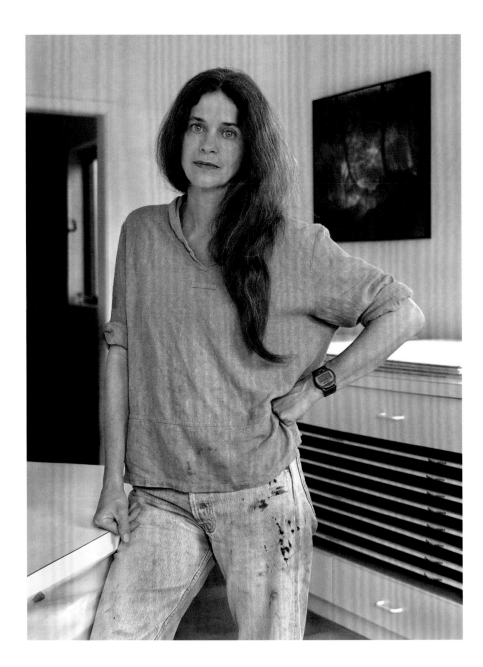

THE CHRONICLER OF PLACE

An indefinable sense of magic or mystery pervades a Sally Mann photograph, whether of her children, husband or a landscape in her beloved American South. At the same time, her images – made using a variety of analogue processes – are firmly rooted in reality, as physical and temporal as photographs can be. This is not the only ambiguity at play, however; behind the apparent tranquillity lies a hint of darkness or uneasiness.

Throughout her decades-long career, Mann has been fascinated by the areas of human life that the light does not penetrate: the upsets, ills and traumas of childhood; the slow, merciless march of disease (Mann has photographed her husband who has muscular dystrophy); the terrible histories of slavery and racism where she was raised and lives still; and the end that awaits us all – death (her series, 'What Remains', includes images of decomposing bodies gradually disappearing into the land). Mann has never shied away from, and instead embraces, the uncomfortable truths her medium brings so sharply and sometimes brutally into focus.

Born in Lexington, Virginia, Mann took up photography at school. Her father was a doctor who made art and encouraged her interest in taking photographs. Her mother ran a bookshop. Studying literature as an undergraduate, Mann earned a master's in creative writing, honing her photography skills in photography workshops along the way. Using an 8×10 camera, Mann's early work included an exploration of adolescence, including the complex emotions and experiences that go along with growing up, a theme she explored at length in the photographs of her three young children made from 1985 to 1994. Everyday activities such as eating, playing and sleeping, as well as the ups and downs of childhood, were her subject during this time, each scene – immaculately envisioned – somehow elevated from the ordinariness from which it originated. Mann published images from this period as the landmark book, *Immediate Family* (1992), which brought fame and admiration as well as controversy.

In the mid-1990s, having already used the platinum process to print her work, Mann began making collodion prints of landscape photographs taken in her native Virginia, Georgia and much of the deep South, including Mississippi and Louisiana. History weighs heavy on these landscapes. Although they are as beguiling and as seemingly timeless as her images of family, the photographs, often described as eerie or haunting, allude to a tragic blood-spilled past where immeasurable suffering and injustice took place. Always willing to embrace the intrinsic capriciousness of her medium, Mann took some of the photographs with an antique lens, which contributed further to the unpredictability of the outcome. Other images were shot on high-contrast film to exaggerate light and dark areas [41].

Mann's photographs form an unparalleled body of work. Their beauty lies in their ability to speak to the most ordinary and familiar of human experiences and emotions and yet transport us to places we can only dream of.

CREATE A SILHOUETTED LANDSCAPE

Sunset is a magical time to photograph, not only because of beautiful golden light, but because it's possible to use that light to create striking silhouettes of trees in the landscape.

Choose a scene with strong, graphic shapes. Try getting down low and shooting up to include as much sky in the frame as possible. Working with manual exposure, take a light reading for the sky. Make an exposure and look at it on the screen on the back of your camera (if you are using a DSLR). Increase your exposure to darken the shadows, if required, or decrease it to adjust for an over-exposed sky.

Untitled (Weyanoke Estate, Louisiana)
from 'Deep South', Sally Mann, 1998

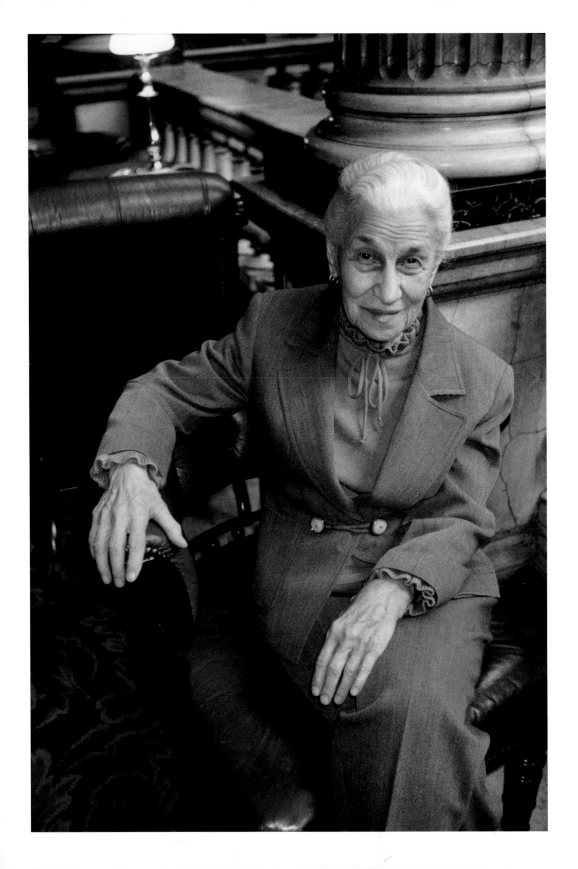

EVE ARNOLD

American
1912–2012
Photojournalism
Portraiture

THE CONFIDANTE

Tina Modotti was not the only photographer who was fascinated by hands (p. 24). In her long and distinguished career, which took her all over the world, photojournalist/documentary photographer Eve Arnold also photographed people's hands (and sometimes feet). Most famously, she shot the hands of a mother and her newborn baby for *LIFE* magazine. She photographed hands in the way she photographed every subject: with great compassion and a genuine interest in her subject matter. Such qualities, and the intimate and naturalistic approach she took, became the hallmarks of her deeply human photography.

Arnold, who was born in the United States to Russian immigrant parents, began her photography career as a supervisor in a photo-finishing plant. She had studied medicine but abandoned this in favour of photography. Briefly studying under the famous art director, Alexey Brodovitch, Arnold embarked on a photo project that took her behind the scenes at a fashion show in Harlem, New York. Despite some 300 fashion shows taking place in Harlem each year [42], the eyes of the fashion press were frequently fixed elsewhere. Arnold's reportage featuring Black American models revealed another side to the fashion industry, one that went out of its way to defy traditional codes. Her work helped to bring attention to an under-reported scene. The raw, honest images she made in Harlem, including of the Black Power movement, launched her career. A selection was published in *Picture Post* in London and she was later accepted by the photographic agency Magnum Photos. Arnold was among the first female photographers to join the photographer-owned collective.

It would not be the last time Arnold photographed women. She made images of women from all walks of life throughout her career: a girl in a brothel in Havana, Cuba; women and their malnourished babies in South Africa; a migrant female worker in New York; and, most famously, Marilyn Monroe, whom she photographed over a decade. The actresses Elizabeth Taylor, Joan Crawford and Marlene Dietrich were also her subjects.

It did not matter how well known the person was: Arnold photographed with the same immediacy and care. She had a unique ability to spot and capture the tiniest flickers of emotion, creating often tender images that drew viewers into her subjects' worlds. Many of these images were included in her first book, *The Unretouched Woman*, published when Arnold was in her 60s. Her aim with the publication was to explore the experience of being a woman from a female perspective. As she wrote in a characteristically forthright way: 'I am a woman and I wanted to know about women.' [43] It was these 'uniquely female but also uniquely human' [44] stories that Arnold was so adept at telling.

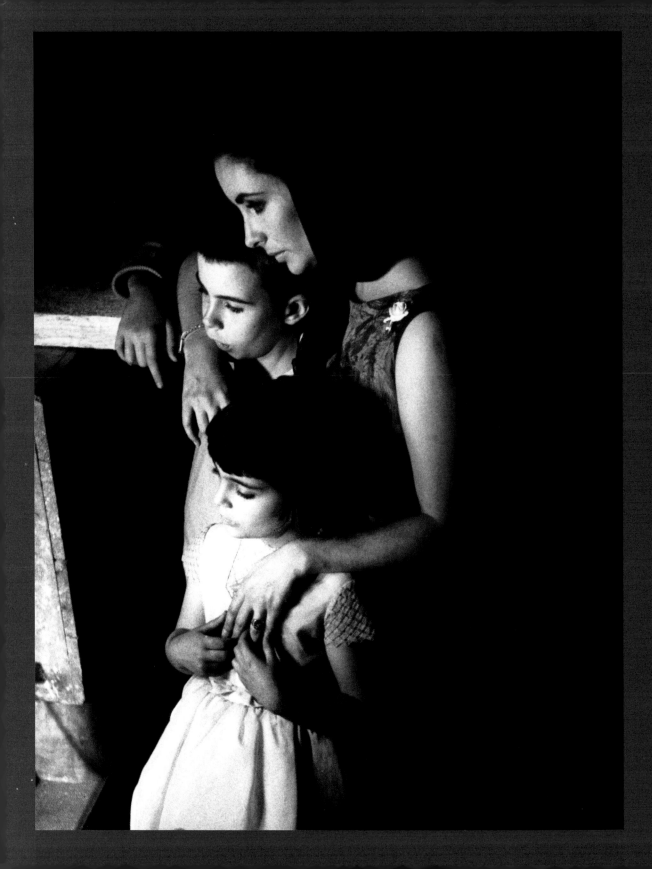

CAPTURE CANDID FAMILY PORTRAITS

Eve Arnold believed that a subject, if treated with care, would offer something of themselves to the photographer. She was right that the more you help your subject to feel at ease, the more likely you are to come away with photographs that look authentic. While Alice Austen shows us how to take posed portraits (p. 32), Arnold reveals how to create an image featuring several people that is more spontaneous.

The key is to spend time with your subjects before you start photographing. Pay attention to how they interact. Create an environment where your subjects are comfortable and let them get used to you and the camera. If there are children, show them your camera and involve them in the process. Pay attention to faces and hands and make sure that people's eyes are in focus.

Elizabeth Taylor with her daughter on the set of the film Becket, *watching Richard Burton playing a death scene, Eve Arnold, 1963*

CINDY

American
Born 1954
Art
Portraiture
Performance

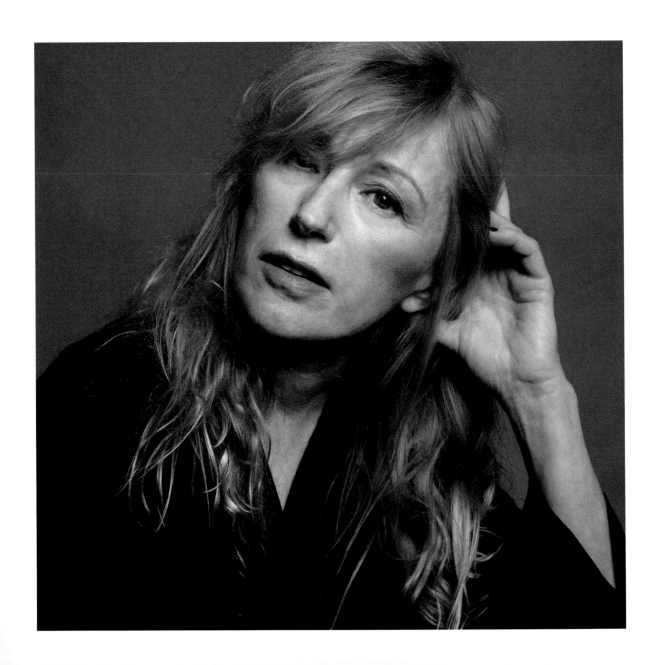

SHERMAN

THE CHAMELEON

From clowns and silver screen sirens to society women to art history figures, Cindy Sherman has portrayed multiple personae throughout her long career. Although Sherman, who lives and works in New York City, always features in her artworks, they are not about her. Rather, Sherman uses costumes, props, set designs, wigs, makeup, poses and prostheses to explore familiar 'types' of people, usually women, from mass media, film, fashion, art history, history and more. Importantly, her intention is not to recreate specific people but to use the characters she painstakingly creates to comment on social mores and to question the construction of appearance and identity. As a child, Sherman watched hours of television and devoured films eagerly. Fascinated by the feel of fabric, the artist, who was born in Glen Ridge, New Jersey, liked to dress up in clothes that were lying around and enjoyed making herself up, creating surprising, unconventional characters. This period of childish make-believe would prove to be more than a passing phase: it became the bedrock of her art.

Initially studying painting at Buffalo State College (now University), which she attended from 1972 to 1976, Sherman turned to photography and began to put herself – in character – into the frame. In 1975, she made the series 'Untitled', her 'first real work of art' [45], which features black-and-white images of Sherman transforming from a schoolgirl to a pin-up. In these early images, Sherman's focus is primarily on the face and how this can be changed using makeup. Her focus shifted just a few years later with her breakthrough and most famous body of work, 'Untitled Film Stills' (1977–1980), the images of which take place in (highly staged) surroundings and are more narrative in scope. In these images, which recall stills taken on a film set used to publicize a film, Sherman draws on cinematic conventions or styles including film noir, old Hollywood, European art-house and B-movies. With their sidewards glances and sometimes uneasy demeanour, the women, all played by Sherman, are familiar stereotypes – vamp, housewife, ingenue – pictured in apparently hastily caught, in-between moments. In these images, which are laden with suspense, ambiguity reigns supreme. The images deftly question – and invite viewers to speculate about – stereotypical depictions of women in cinema.

Sherman's intention, however, has never been to preach or to peddle overt feminist arguments. Instead, she specializes in the creation of implied narratives, her interest firmly in exploring the tension between appearance and reality, the construction of identity and of the image itself, and the notion of disguise, artifice or transformation. Linked to 'The Pictures Generation', a loosely affiliated group of artists from the early 1970s to the 1980s whose work mocked mass-media imagery, Sherman has always been one step ahead. In the last two decades or so, she has used her work to comment on ageing and the portrayal of older women by the media. Sherman has also used digital technology to manipulate her images and made cartoonish Instagram selfies. It is no exaggeration to say that her influence on the way artists and others approach, or think about, portraiture and photography has been profound.

COMBINE AND BLEND MULTIPLE PORTRAITS IN A SINGLE IMAGE

Making an image with a nod to Cindy Sherman starts by playing dress up. Sketch out how each character will look down to the makeup, hair style and accessories. Think about the facial expressions and pose. Shoot each portrait separately, making sure the exposure and lighting conditions are constant.

You may also want to shoot a standalone background image. Create a new document in Photoshop and drag in your first (background) image. Drag more image files from your computer into the document. Each image will become its own layer. Use the Move tool to fine-tune the position of each portrait and mask layers to hide and reveal parts of your composite image.

Untitled #577,
Cindy Sherman, 2016

FRANCES BENJAMIN

American
1864–1952
Architecture
Documentary
Portraiture

JOHNSTON

THE RADICAL

A formidably successful photographer, both financially and in terms of professional reputation, Frances Benjamin Johnston, who was born in West Virginia and raised in Washington, D.C., was one of America's earliest women photojournalists. Her varied career spanned more than five decades and took in myriad subject matter, including images of women at work, celebrity portraits and architecture. One of her most notable endeavours was the work she made at Hampton Normal and Agricultural Institute in Virginia (now Hampton University) in 1899 and 1900. The exquisitely composed images depict African American students engaged in all kinds of activities, including woodwork (p. 139). She co-curated an exhibition of work by 28 women photographers for the 1900 Exposition Universelle in Paris.

After studying drawing and painting at the Académie Julien in Paris from 1883–1885, Benjamin Johnston returned to Washington, D.C. and continued her studies at the Art Students League. Setting aside an ambition to become a magazine illustrator, Benjamin Johnston took up photography instead. Receiving tuition from the photographer and curator Thomas Smillie of the Smithsonian Institution, Benjamin Johnston opened a commercial portrait studio in 1894. She was purportedly the only woman photographer to be working professionally in the area at the time [46].

Making her living from portraiture, including photographing well-known figures of the day – US presidents, the women's rights activist Susan B. Anthony and author Mark Twain were among her subjects – Benjamin Johnston also did news and documentary photography, later turning her attention to photographing architecture and gardens. Her first architectural commission to photograph the New Theatre in New York came in 1909. From 1913–1917, she and fellow photographer Mattie Edwards Hewitt, with whom she was romantically involved, ran a studio specializing in house and garden photography. Among her most celebrated achievements was the extensive grant-supported survey of historic buildings in the Southern United States made between 1927 and 1944. For this opus, Benjamin Johnston photographed in nine states, among them Virginia, Maryland, North Carolina and Louisiana, for the Carnegie Survey of the Architecture of the South. The purpose of the project was to create visual records for posterity and generate interest in American architectural history.

Benjamin Johnston was not shy about displaying and celebrating her independence and success. From early in her career, she made a show of her defiant spirit, famously photographing herself with a cigarette in her hand and her skirts outrageously pulled up to show her stockings and petticoat. Not dissimilar to Alice Austen (p. 32), she too made photographs of herself dressed up in male clothing. Calling for more women to enter the male-dominated profession of photography, Benjamin Johnston set out in her oft-cited 1897 article for *Ladies' Home Journal* titled 'What a Woman Can Do With a Camera' why she believed women should take up photography professionally. She also shared her views on what it took to build a successful, profitable photography career. According to Benjamin Johnston, women must have determination, patience, be good-natured and 'business-like' [47].

COMPOSE A DYNAMIC PHOTOGRAPH
OF PEOPLE AT WORK

You can immediately tell the care with which Frances
Benjamin Johnston has composed this photograph.
Each figure, engrossed in his own task, is precisely
placed within the frame, and yet the image works
because of the way the separate elements come
together into a cohesive whole.

Seek out a similar scenario – workers on a building
site, road workers or market traders. Don't stray onto
private land, but remember that you have a right to
photograph in a public space. Be prepared to explain
in a friendly way what you are doing. Confidence,
respect and good communication are key when
photographing in public. Practise looking at how
people and elements of a scene can be brought
together in the frame in a dynamic way. Always be
aware of your surroundings to keep yourself and
others safe.

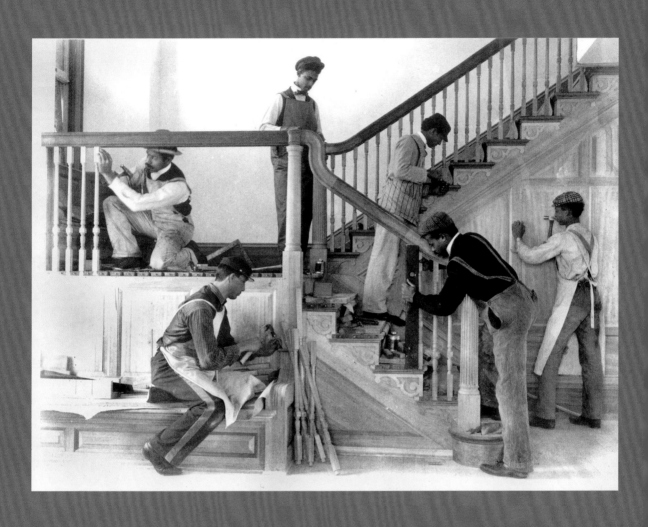

Stairway of the Treasurer's Residence:
Students at Work from the *Hampton Album*,
Frances Benjamin Johnston, 1899–1900

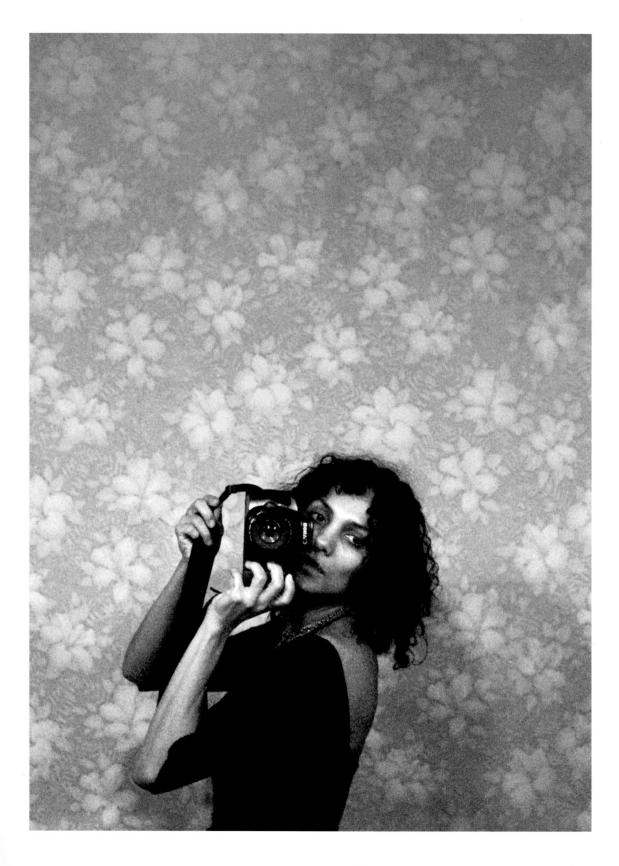

MING SMITH

THE IMPROVISER

American artist Ming Smith is a woman of at least two photography firsts. In 1978, the Museum of Modern Art bought some of Smith's work, making her the first African American female photographer to have work acquired by the museum. Smith was also the first woman to join the influential Kamoinge Workshop, a collective of Black photographers founded in 1963 whose mission was to depict Black communities as they saw and experienced them and to propel photography forwards as an art form.

Smith has always been her own photographer, quietly and diligently documenting, in her unique way, the lives of Black people in her home country and elsewhere. With their poetic sensibility as well as uplifting compositions, her images poignantly reveal the humanity and spirituality of African Americans and celebrate Black culture.

Born in Detroit, Michigan, Smith was raised in Columbus, Ohio. She had intended to go to medical school, but after studying microbiology and chemistry at Howard University, decided against medicine as a profession. Her father, a keen amateur photographer, suggested she become an artist instead. The idea stuck. Smith moved to New York in the early 1970s where she worked as a model and a dancer. She attended go-sees – photoshoots for photographers who were building their portfolios – and made her own photographs as often as she could. Before long, Smith was invited to join the Kamoinge Workshop, a move that would prove transformative for the young artist. The collective's unwavering commitment to photography as an art form resonated deeply with her, and Smith went on to dedicate her life to photographing the Black experience.

Smith's use of movement and blur became central to her visual signature. Usually shooting with black-and-white film, Smith would often use a slow shutter speed to capture a moment, resulting in images that possess an indefinable yet undeniable energy. That moment could be anything – a word or an exchange between two people, a momentary look or gesture. Smith kept her camera with her most of the time and anything could draw her eye.

Often playing with what is seen and not seen, Smith used light and shadow as a painter uses paint, carefully positioning these things in the frame as the mood took her. The result is images that feel urgent and visceral, and not of this world. 'Improvisatory' is another word often used to describe Smith's approach to image-making and the artist herself has talked about the parallels between the way she makes pictures and how a jazz musician riffs and improvises. It's about timing, she has said; instinct and intuition are everything.

Despite Smith's early success, attention fell away from her for many years. Now that is beginning to change, with the artist receiving attention and recognition in the art world, media and elsewhere.

American
Art
Documentary
Portraiture

GET CREATIVE WITH BLUR

Many of Smith's most mesmerizing images hint at what is happening inside the frame, rather than explicitly show what is going on. You could try something similar, perhaps in low light.

Creating motion blur is all about controlling your shutter speed. Working in 'Shutter Priority' AE mode (AE means 'automatic exposure') allows you to do this, leaving the camera to set the aperture. How blurry your subject will look will depend on the available light and how fast your subject is moving but a 1/10th second is a good place to start. Hold your camera steady and check that your 'Image Stabilization' (IS) mode is on to avoid any unwanted movement. As ever, take time to compose your shot. Composition is especially important when creating images with blur. A poorly composed image can appear as though the camera has been wobbled accidentally.

*Amina and Amiri Baraka
(Lovers)*, Ming Smith, 1980

SHIRIN

Iranian-born
Born 1957
Art
Mixed media
Portraiture

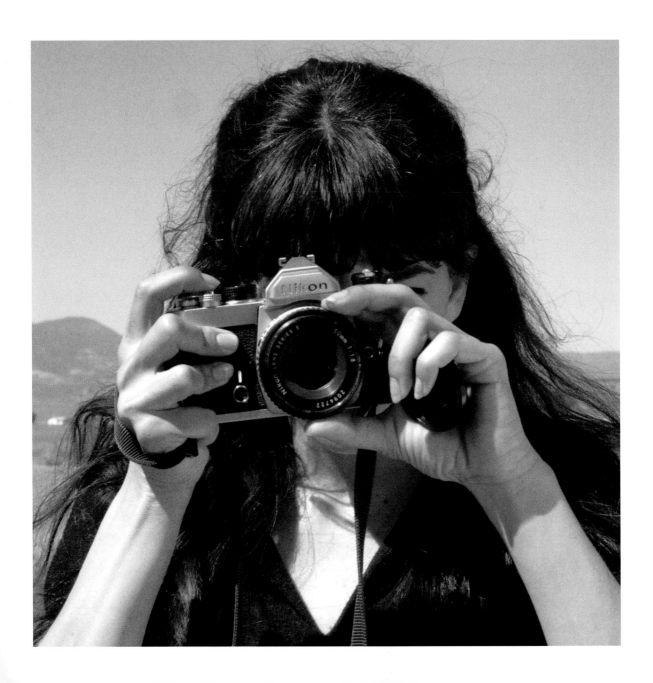

THE FREEDOM FIGHTER

In one of Shirin Neshat's most famous artworks, *Rebellious Silence*, from the acclaimed series 'Women of Allah', a rifle divides a face – the artist's – cleanly in two. Like this iconic piece, Neshat's work comprises many binaries, among them: fragility and strength; aggression and vulnerability; speech and silence. Indeed, the overlaid handwritten Farsi text – Persian poetry – can be interpreted as a symbol of voices that paradoxically 'speak out' and are stifled. On the surface, the women look 'passive and silent', Neshat has said, alluding to the oppression against women in her birth country of Iran, 'but underneath there is lots they want to say, and this is expressed through the calligraphy.' [48]

For decades, Neshat has explored her own experiences, emotions and thoughts about issues close to her through art. In particular, she has explored what it's like to be an Iranian living in the United States of America, what it means to feel displaced, the loss and absence of home, and the trauma of separation. These are recurring themes. More recently, she has explored life – specifically political tensions – in her adopted country.

Born into an educated family in the conservative and religious city of Qazvin in Iran, Neshat, encouraged by her parents, went to study in the United States in the mid-1970s. Aged 17, she moved to California, obtaining an art degree from the University of California, Berkeley. The Iranian revolution in 1979 made it difficult for the artist to return home, and when Neshat did travel back to her birth country many years later, she found it to be a much-changed place, not least regarding the strict laws directing that women wear the hijab in public.

Motivated to make work about the female experience in Iran, as well as explore a personal need to 'reconnect', Neshat, who is based in New York City, produced 'Women of Allah' (1993–1997), drawing on the experiences of Iranian women associated with the revolution. The multilayered, tightly woven artworks are both visually and conceptually complex, seamlessly bringing together photographs with fragments of poems by contemporary Iranian writers, Tahereh Saffarzadeh and Forough Farrokhzad. In these works, Neshat explores themes such as feminism, religion, fundamentalism and the female body as a site of contention and oppression. Contradictions and tensions abound, not least in the collision of traditional values and femininity with implied violence.

Neshat also works with film and has produced works such as the acclaimed double-channel video installation *Rapture (1999)* and *Women Without Men* (2009), her first feature-length film. She has multiple accolades to her name, including the First International Prize at the 48th Venice Biennale in 1999 and the Silver Lion at the 66th Venice Film Festival in 2009. An artist who has carried the burden of living and working in exile, between cultures, with her for decades, Neshat channels feelings of loss and longing into her defiant art with remarkable skill and effectiveness. In a turbulent world where oppression against women remains, not least in Iran, Neshat's work is as fresh and vital as ever.

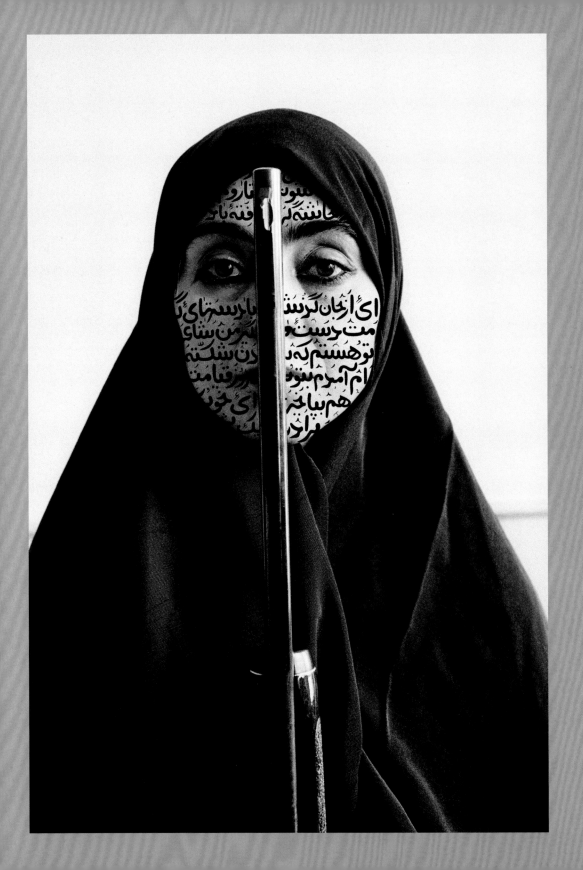

USE TEXT TO CREATE POWERFUL IMAGES

Working in Photoshop or similar, try overlaying a scanned piece of handwritten text onto an image you've taken. In Shirin Neshat's work, you will find words on hands, feet, fingers, faces and even eyes.

A more hands-on approach could involve making a photographic print and painting or drawing directly onto the paper. You could write a poem or a short piece of prose. Thinking about the size of the words and their placement on the page, keep in mind the impact the text will have when viewed in conjunction with the image.

Rebellious Silence,
Shirin Neshat, 1994

SUSAN

American
Born 1948
Documentary
Photojournalism
Portraiture

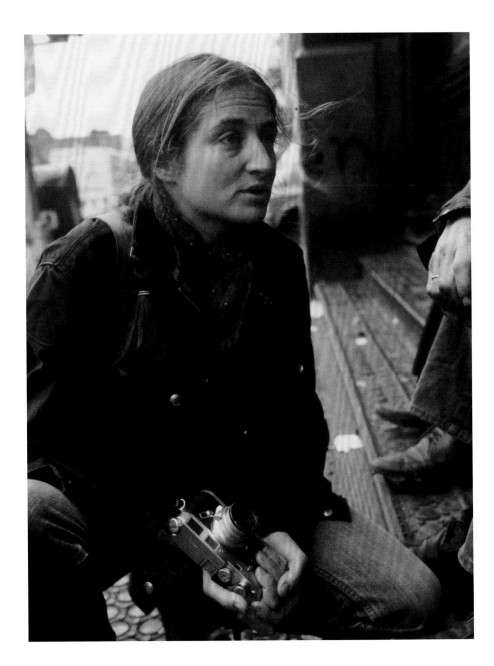

THE TEAM PLAYER

How many of us return to a place where we have taken a photograph months or even years later? Susan Meiselas does, sometimes literally taking her photographs back to their place of origin as she did in 2004 for the project, 'Reframing History', which saw her go back to Nicaragua and install 19 murals with her images where they had been created.

For the duration of her decades-long career, Magnum photographer Meiselas, who was born in Baltimore, Maryland, has put an emphasis on collaboration, which can be many things: it has meant showing photographs she made to her subjects and asking for a response, as she did early on in her photography career in the project, '44 Irving Street' (1971); engaging in workshops with women in a refuge in the Black Country (West Midlands), exploring their experiences by piecing together narratives from images, original artwork and first-hand testimonies as she did between 2015 and 2016 for her book, *A Room of Their Own* (published in 2017); and giving point-and-shoot cameras to her subjects before reproducing and installing their photographs and her own on the streets of their own community as she did in 'Cova da Moura, Portugal', working with local young people [49]. For Meiselas, collaboration is about immersing herself in a place, getting to know her subjects and inviting them to be part of the creation of their narrative.

Studying for a master's degree in visual education at Harvard, Meiselas had no formal photography training, but had been exposed to photography from a young age. When she was a teenager, she was given a camera by her father and, as an undergraduate, travelled the world with her camera, taking in the cultures she experienced. Among her most famous work is her American carnival strippers series, made over three summers between 1972 and 1975, for which she photographed dancers performing and in private moments backstage. The work told a story of their lives at a time when the women's liberation movement was gathering momentum. She also recorded interviews with the women and others (partners, managers, customers), which were played as a soundtrack when the images were exhibited – an approach that few, if any, photographers were exploring at the time. Years later, in 1998, Meiselas launched a website – an online archive – akaKURDISTAN, which brought together many years of research to tell a history of Kurdistan and the Kurdish people. She is also known for her work in Nicaragua (1978–1979) documenting the Sandinista revolution. The intensive research Meiselas did for decades afterwards to track down the people in her images added additional layers to the original work.

Her commitment to not only bearing witness to some of the most important moments of our time, but involving her subjects in the dedicated way that she does – prompting questions about authorship – and coming up with new ways to engage an audience time and again has made Meiselas a towering figure in photography.

ASK YOUR SUBJECT TO RESPOND TO
A PORTRAIT YOU HAVE TAKEN OF THEM

For her final project as part of a photography course she was studying in the early 1970s, Susan Meiselas made a 4×5-inch portrait of each of her neighbours in the boarding house where she was living in Massachusetts. She gave her subjects a print of the portrait she had made and asked them to write down their response on seeing it. Their responses added context and formed a key part of the project.

Next time you take a portrait, make a print and show it to your subject. Think about how you could incorporate their response into the artwork, perhaps as a separate panel as Meiselas did or by inviting the person to write directly on the print.

I like living at 44 Irving St. I
think it's nicer than most rooming
houses (no dirty old men). I like
having people around + I also
need lots of privacy which I can
get by closing my door.
 When you share an apartment
with roommates you have too many
obligations + this leads to hassles.
I also like living in a male/female
house. 44 Irving St. is such an
interesting mish mash. It's a good
cross-section of our luney-bin society.

I don't think the photo of me really
gives the essence of me. In it I
look very serious + quiet + contemplative.
It looks more like me when I was
12 + daydreamed a lot. Now I'm
more energetic + restless.

 Joan

*Joan, 44 Irving Street, Cambridge,
MA, Susan Meiselas, 1971*

RINKO

Japanese
Born 1972
Art
Landscape
Portraiture

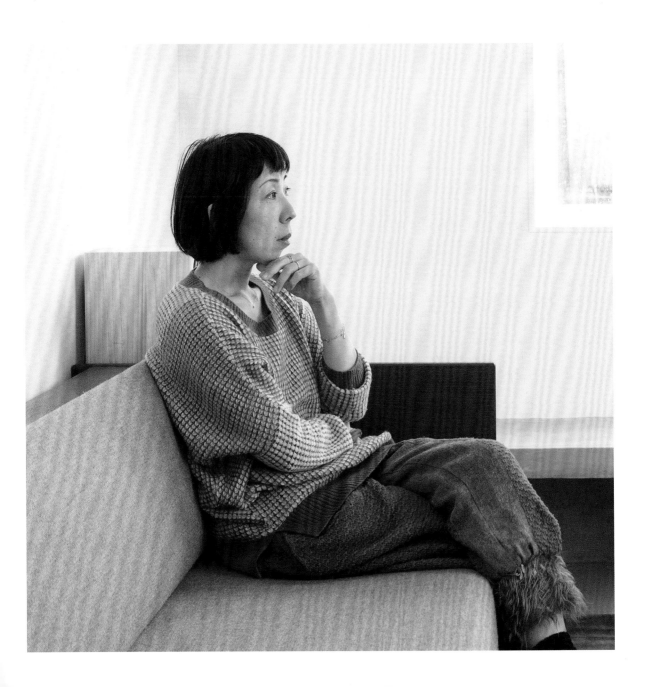

KAWAUCHI

THE ILLUMINATOR

In a rich and long tradition of Japanese (mainly male) photographers working in black and white, Rinko Kawauchi's quietly sublime, delicately coloured work is captivating. Kawauchi began making photographs in black and white in her late teens, but shifted to colour photography after a few years. A giant in photography, not just in her home country of Japan but worldwide, Kawauchi is renowned for her breathtaking use of colour and natural light and has a unique ability to capture and make beautiful life's seemingly inconsequential moments.

Born in Shiga on the island of Honshu, Kawauchi studied graphic design at Seian University of Art and Design. She took photography classes while at university and, after graduating in 1993, worked in the graphic design and photography department at an advertising company. Photographing commercially and continuing to develop personal work, Kawauchi began to assemble a considerable body of work. In 2001, she published three books of her photographs, which effectively launched her career. Having held exhibitions of her work in Japan before this breakthrough, Kawauchi has gone on to exhibit internationally in the decades following. The book, however, has remained a natural home for her work. Agreeing that her background in design has proved useful in this respect, Kawauchi has published more than 20 photobooks.

A private person about whom little is known outside her work and working methods, Kawauchi has spoken candidly about what compels her to make the photographs she does and her photographic approach. Usually using a 6×6 Rolleiflex camera, Kawauchi is guided by intuition. She speaks about the process of making work as being like meditation and a collaboration, describing individual photographs as a 'single cell, or a single voice' that form a body of work when they resonate with each other [50]. Indeed, while each image she creates is a perfectly formed self-contained entity, it is through the images in sequence that we feel the full effect of her work's power to effortlessly transport viewers to another realm. Drawing inspiration from the Japanese religion of Shinto, which promotes the idea that everything has a spirit or spiritual essence, Kawauchi has an ability to move between the micro and macro, crafting images that seem to be suspended between dreams and reality, sight and what a mind's eye might conjure. There is an intimacy in her work – we sense Kawauchi's presence – but also a universality. Ordinary moments that border on the banal – a glowing cigarette, a light-drenched road, a pair of feet – are made magnificent. But there is an uneasiness or an uncertainty at play. Death and pain make their presence felt at times, although even then beauty is never far away.

With their resplendent and, at times, seemingly divine light and subtle pastel shades, Kawauchi's photographs render the ephemeral and the intangible real, at least in photographic terms. Hers is an 'everyday existentialism' [51] that feels familiar, comforting, but at the same time unsettling and strange.

MAKE BOKEH THE SUBJECT OF YOUR IMAGE

Meaning 'blur' in Japanese, bokeh is the term used to describe the appearance of blurry, out-of-focus areas in a photograph. The effect is often used to disguise distracting backgrounds, but it can also be the subject of a photograph.

With your camera set to 'Aperture Priority' or 'Manual' mode, and using a fast lens (with a wide aperture), have a go at photographing points of light out of focus. Try filling the frame and think about creating a composition with multiple areas of interest. Photograph different types of light – for example, fairy lights – and use colours to create a range of effects. Try reflecting light from a lamp using crumpled foil to create a shower of scattered highlights.

Untitled from 'M/E',
Rinko Kawauchi, 2020

POULOMI

Indian
Born 1983
Documentary
Mixed media
Portraiture

BASU

THE ACTIVIST

Artist and activist Poulomi Basu knows first-hand what it is like to be on the receiving end of misogyny and violence, two enduring themes in her work. Born in Kolkata, India, Basu was raised in a traditional patriarchal family. At the age of 17, Basu's father died, and her mother told her to leave home if she wanted to have choices in life. Basu did that, studying sociology and then photojournalism and documentary photography at the London College of Communication. She has gone on to make important bodies of work that investigate systemic injustices and violence against women and bring marginalized voices to the fore.

Working with photography, moving image and installation, Basu has said she produces work about the 'psychological and emotional spaces' that women find themselves in, and the journeys they make [52]. Her first major series, 'To Conquer Her Land' (2009–2012) tells a story of women soldiers – India's first – of the Border Security Armed Force who were deployed in the infamously dangerous and sometimes lawless border areas of Punjab, Jammu and Kashmir. Spending time with the women at boot camps and on the frontline, Basu photographed her subjects in black and white and in colour, sometimes creating blurry images, crafting a narrative that comes in and out of focus like visions in a dream. The women might be fighting an enemy on the ground, but there is a sense that they are fighting patriarchal attitudes for their rights as women. This multilayered approach, where meaning is inferred, is typical of Basu, who is interested in playing with metaphor and ambiguity so that 'the mind [can] travel and ask questions.' [53]

Often embedding herself in remote communities, Basu is committed to bringing under-reported stories and issues to light. She did this for 'A Ritual of Exile' (2013–2018), which examines the ancient Hindu practice of chhaupadi, whereby menstruating girls and women, and those undergoing postpartum bleeding, must reside in makeshift huts because they are considered impure. In addition to a lack of medical supplies and assistance and exposure to the elements, there is the threat of rape and murder. Always looking to evoke feelings of empathy in her audience and to create an immersive experience, Basu exhibited the work in a multimedia environment using projections, lightboxes, sound and virtual reality.

Basu is also interested in questioning the nature of truth in her work, a topic she explores in the acclaimed *Centralia* (2010–2020). A 'docu-fiction' in which Basu combines documentary and almost fantastical approaches, the work tells the story of the little-known and ongoing conflict between women guerrilla fighters – an indigenous tribal people – and the Indian state for land, exploring how perceptions of truth and reality are manipulated.

Recently, Basu has put herself in her work. In 'Fireflies', she responds to her traumatic past. Commenting on the emblematic significance of the firefly, Basu acknowledged a central duality at play in the work: 'Fireflies glow in the darkness. So, there is both this element of something free, pulsing and magical, yet dark. I associate that with feminine powers. Women are powerful and magical [and] yet there is a lot of struggle laced in our history and constant battleground of misogyny and patriarchy.' [54]

DEFOCUS YOUR LENS TO CREATE IMPACT

Defocusing your camera lens can give the images you take an eerie, otherworldly feel.

Focusing manually, try photographing a group of people in a landscape, adjusting the focus to fine-tune the defocus effect. You could try photographing at night, using moonlight to light the scene, for added impact. If shooting in the day, use ISO 400 as a starting point and manually control your exposure, adjusting as needed. Aim for a bright exposure, as adjusting the brightness levels afterwards will reveal shadow noise. Convert your images to black and white in Photoshop.

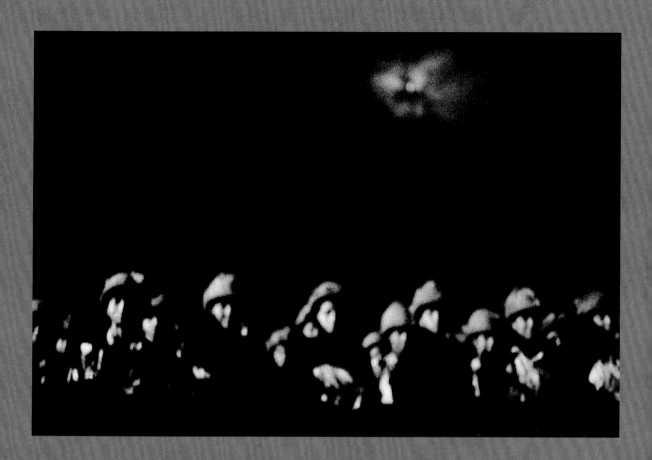

From 'To Conquer Her Land',
Poulomi Basu, 2009–2012

KARIMEH

Palestinian
1893–1940
Documentary
Landscape
Portraiture

THE ENTREPRENEUR

A courageous woman with an irrepressible entrepreneurial spirit, Karimeh Abbud has been credited as both the first Arab woman photographer and the first in Palestine [55]. Born into an educated middle-class Christian/Protestant family in Bethlehem, Abbud began taking photographs of her local area and family at the age of 17. After studying Arabic literature at the American University of Beirut, she worked as a teacher before committing to a career in photography. Religious and historical sites, as well as Palestinian cities, landscapes and people, including peasant folk and middle-class families, weddings and other family events, were among her subjects.

It was the early 1920s and change was afoot, socially and culturally. Abbud, who had had a liberal upbringing, embraced the changing times as she set about forging a photographic career. Photography was already long-established in the Middle East, but it was predominantly practised by men. Business-minded Abbud used her gender to her advantage. Shrewdly recognising that many of the women (and their families) whom she had made her subject would be more comfortable being photographed in their own home by a woman, she explicitly advertised herself as a 'Lady Photographer' and travelled to them by car. Abbud became known as a trusted pair of hands among the middle classes seeking photographic portraits and was highly sought after. The good feeling her clients bore her is evident in the photographs she made of them: her subjects appear relaxed. Unusually for the time, Abbud set up her own studios in multiple locations across Palestine, extending her professional reach.

Her less formal, candid, sensitively composed and at times poetic images in semi-rural settings reveal the vibrant, thriving character of Palestine and its people. Sometimes, Abbud hand-coloured her photographic prints, accentuating the scenes she had captured. Remarkable visual records of a changing region and time, Abbud's photographs provide valuable documentation of everyday Palestinian life before the Nakba – the mass displacement of Palestinians during the 1948 Arab-Israeli war. Abbud's photographs show Palestine as a bustling, civilized and flourishing region [56].

Despite Abbud's success during her life, her work fell into obscurity for many years. Much of it has been lost. In the mid-2000s, Israeli antiques collector Yoki Boaz put out a call for information about Abbud after acquiring some of her photographs. Researcher Ahmed Mrowat responded and helped to expand the collection. As well as her extraordinary achievements working as a professional photographer at a time when the profession was dominated by men, Abbud is important because of the female perspective her photographs present – women by a woman, a rare thing in Palestine in the early 20th century. Moreover, while Europeans had been travelling to the Middle East since the 19th century to photograph the landscapes, architectural sites and more, Abbud gives us a unique non-foreign/non-Western, non-exoticized view of the Palestinian people.

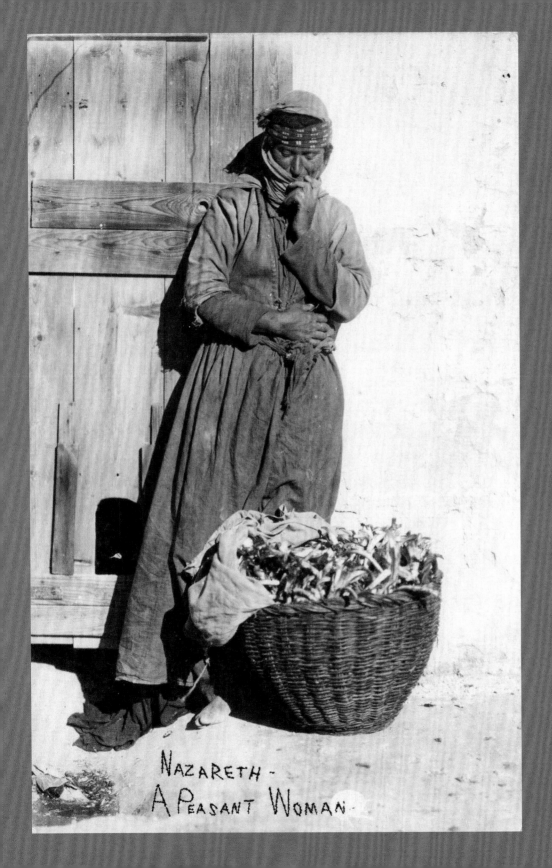

NAZARETH -
A PEASANT WOMAN.

TAKE A BRILLIANT STREET PORTRAIT

A street portrait is different to a street photograph taken on the fly because your subject will likely know you are photographing them. Once you spot a potential subject, start a conversation with them. You'll get a sense as to whether the person wants to engage with you or not.

Once you have their permission to be photographed, think about how you could incorporate the person's surroundings into your image. Work with the light that is available and ask your subject to change position if doing so makes for a better-lit image. Try using a 50mm or 85mm lens. A longer focal length will help you isolate your subject from their surroundings if you're faced with a busy setting.

Nazareth, A Peasant Woman,
Karimeh Abbud, 1925

AMI VITALE

THE CONSERVATIONIST

Photography is a powerful communication tool. Combined with storytelling, it can have even more impact. One person who knows this well is the American photographer and documentary filmmaker Ami Vitale, who uses visual storytelling to raise awareness of some of the most pressing conservation issues of our time. Her work is about animals and humans, inextricably linked – her ethos being that 'you can't talk about humanity without talking about nature.' [57]

Vitale is best known for her award-winning work documenting the story of the last of the northern white rhinos, which she's been covering for the past 15 years. She also spent years covering China's pioneering panda-breeding and rewilding programme and the community-owned Reteti Elephant Sanctuary in northern Kenya, both of which won her World Press Photo awards.

Born in Florida, Vitale earned a degree in international studies from the University of North Carolina. She began her career at the Associated Press news agency in New York, working as a picture editor in the early 1990s. However, her dream was to be a foreign correspondent and after a few years at the Associated Press, she left and moved to the Czech Republic, where she worked for a newspaper before travelling to Kosovo to cover the unfolding conflict. She went on to report from many more conflict zones, including on the African continent, in the Middle East, Afghanistan and Kashmir, her role being, as she saw it, to expose what was going on and to show audiences the terrible brutality taking place.

As time went on, Vitale became increasingly concerned with highlighting what brought people together, rather than what tore them apart. Producing 'timely' images for an incessant news cycle also became less of a priority. It was more important to her to spend longer periods of time in a place, working to make images that resonated long after the news cycle had moved on.

While covering conflict Vitale realized the stories that she was telling about people always linked back to nature in some way. 'If you dig deep enough behind virtually every human conflict you will find an erosion of the bond between humans and the natural world around them,' she explains on her website [58]. Her focus shifted to telling stories about wildlife, environmental issues and the impact of humans for good and for ill.

A photographer for *National Geographic* and a Nikon Ambassador, Vitale, who has been named as one of the most influential conservation photographers of her generation, is also a prolific public speaker and an educator. She has much sage advice to share about the craft of photography, not least reminding us that great photography comes from good storytelling.

American
Born 1971
Conservation
Documentary
Photojournalism

MAKE A PHOTO STORY TO RAISE AWARENESS
OF AN IMPORTANT ISSUE

A lot of time goes into researching and planning
her photo stories, but it all begins with a subject
that Vitale cares about. Contrary to popular belief,
you don't have to travel far to find a story to tell.
Perhaps there is a local issue you would like to
raise awareness about. It could be something that
appears quite inconsequential, but has the potential
to become an in-depth body of work.

Whatever your subject, make sure it's something
that matters to you and that can be developed over
time. Sketch out your narrative, plotting in various
types of shots such as close-ups, portraits and
other 'scene-setting' images that best tell the story.

*Mary Lengees is greeted by Shaba,
who was the matriarch of the orphaned
baby herd of elephants at Reteti Elephant
Sanctuary in Kenya, Ami Vitale, 2017*

CLAUDE

French
1894–1954
Art
Performance
Self-portraiture

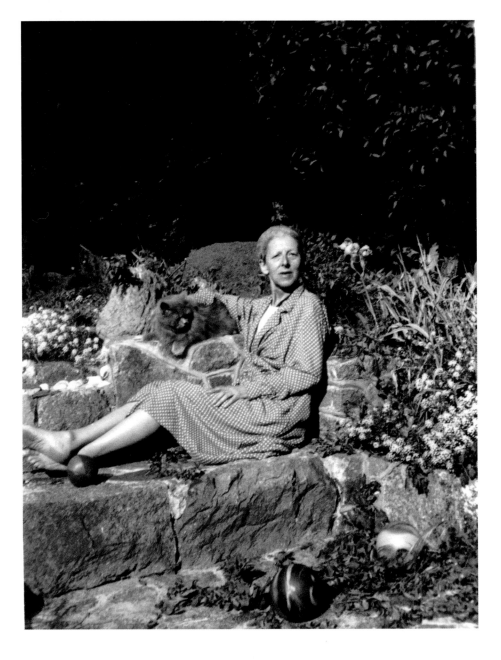

THE ICONOCLAST

An 'enigma', a 'radical', 'revolutionary' are among the words often used to describe the French artist and writer Claude Cahun, whose exploration of gender and identity in the early- to mid-20th century through writings, photography and photomontage was way ahead of its time. But none of these words, or others frequently used in the same sentence as Cahun, quite cut to the core of the surrealist who famously declared: 'Masculine? Feminine? But it depends on the situation. Neuter is the only gender that always suits me.' Perhaps it is less to do with the words themselves and more that the gender-nonconforming Cahun defied definition.

Often referred to as a precursor of Cindy Sherman (p. 132) and Gillian Wearing, both of whom use photography to deconstruct the notion of identity, Cahun, who was born into an affluent Jewish literary family, was a true original, an innovator who explored the self as subject long before camera self-portraits were widely practised.

Born Lucy Schwob in Nantes, France, Cahun used the pseudonym Claude Cahun – 'Claude' because it is a given name for both girls and boys, and 'Cahun' after her grandmother Mathilda Cahun. Studying philosophy and literature at the University of Paris, Sorbonne, Cahun, who regarded gender to be a fluid concept and the self as unfixed, began to make self-portraits, which would become a mainstay of her artistic output. Often using costumes and masks, she played various roles in avant-garde theatre, appearing as female, male and androgynous figures. Sometimes, and perhaps most strikingly for the time in which she lived, she appeared with a shaved head. Masks, in particular, featured prominently in her work. A means to obscure or disrupt the gaze, they serve as a symbol of the slipperiness of identity itself and our inability to get to the heart of our own, or indeed anyone else's, identity. 'Under this mask, another mask,' Cahun famously wrote. 'I will never finish removing all these faces.'

Living in Paris during the 1920s and into the late 1930s with the illustrator Marcel Moore (born Suzanne Malherbe), who was Cahun's stepsister, collaborator and partner, Cahun rubbed shoulders with surrealist artists and writers. Towards the end of the 1930s, with war on the horizon, the couple relocated to Jersey, where they became active in the resistance movement. Among their most notable subversive and artistic actions during the German occupation of Jersey was the creation and distribution of anti-nationalist leaflets. The pair were imprisoned and sentenced to death in 1944 after their activities were discovered, but Cahun and Moore were freed when the island was liberated a year later. Cahun made some self-portraits after this period, including a series of Gothic images that seem to ponder death, but her most prolific period of work was behind her. She died at the age of 60, her health having never fully recovered from her time in prison. Until the mid-1980s, when Cahun's work was included in an exhibition on photography and surrealism, the artist had disappeared into obscurity. François Leperlier's 1992 biography, *Claude Cahun: L'Écart et la Métamorphose*, helped to change that and now Cahun's name is increasingly included in photography histories.

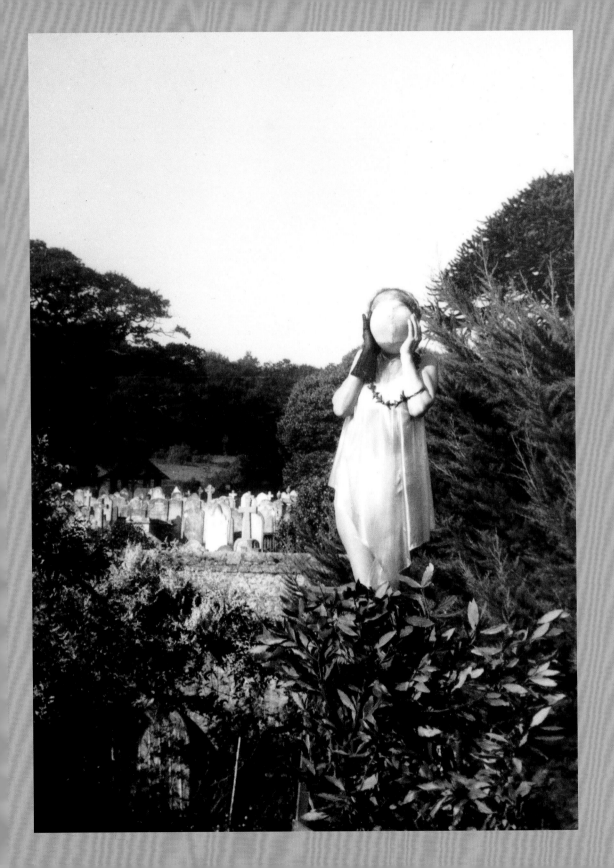

HIDE YOUR FACE TO CREATE AN UNUSUAL, BUT POWERFUL, SELF-PORTRAIT

Sometimes Claude Cahun looks directly into the camera, her challenging stare instantly disarming. Sometimes her eyeline is positioned wryly to the side as though she is watching the viewer in her peripheral vision. At other times, her face is covered completely.

Using a remote shutter release or a timer with your camera on a tripod, make an arresting self-portrait with your face covered. Use a mask or cover your face in some other way, even just with your hands. Alternatively, you could ask someone to operate the camera shutter for you (it is assumed that Cahun's partner Marcel Moore did this for Cahun). The idea is to create an image that disrupts the gaze, triggering an emotional response in the viewer.

Self Portrait (Holding Mask),
Claude Cahun, Undated

CLEMENTINA

British
1822–1865
Art
Fashion
Portraiture

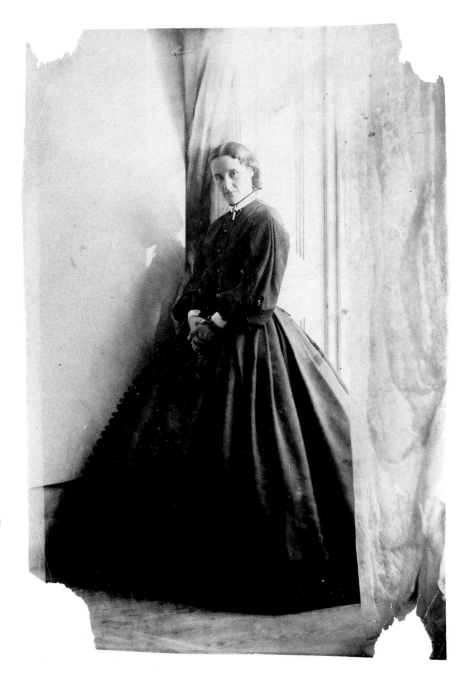

HAWARDEN

THE MIRROR MASTER

One of the most distinguished and innovative female photographers from the earliest days of photography, Lady Clementina Hawarden was an accomplished amateur who made hundreds of portraits of her children, most notably her adolescent daughters Isabella Grace, Clementina and Florence Elizabeth. Born into upper-class society in Cumbernauld, near Glasgow, Hawarden started taking photographs in 1857 on her family's estate in Ireland. When the family moved to London in 1859, she began to make large-format photographs of her children. Creating simple sets from screens, backdrops and fabric used as drapes at her home in South Kensington, she often used a freestanding mirror to bounce daylight onto her subjects – a daringly novel approach for the time. Hawarden also frequently used a mirror to incorporate a reflection – a second image – into her compositions. Just as her contemporaries explored the idea of 'doubleness' through stereoscopic images (two photographs of the same scene at different angles used to create a three-dimensional effect), as she also did, so Hawarden played with the notion of 'the double' in a single photograph, an approach that became a hallmark of her photography.

Given that women photographers of Hawarden's social class were generally unable to travel as their male counterparts could, it isn't surprising that Hawarden sought alternative ways to add dynamism to her images. She had to make the best of the domestic setting. Never short of inspiration, Hawarden used props and clothing in imaginative ways. Her daughters were dressed in traditional clothes and costumes, adding a theatricality to the images. Remarkably for the time, Hawarden's subjects were often posed in sensual ways, leading critics to interpret her work as an exploration of female sexuality. Hawarden has also been described as an early fashion photographer because of her fascination with the way fabric falls and how it looks when photographed, although the term was not used at the time.

Another example of Hawarden's pioneering approach to portraiture is the way she used what was around her subject in each composition – in other words, making the surroundings a key part of the image. The figure was always the principal focus but the inclusion of the environment introduced an important new dimension, setting her apart from other photographers such as Julia Margaret Cameron who often filled the frame with a subject. By working in this way, Hawarden was breaking new ground, her images akin to what we think of today as narrative portraits.

Hawarden was just 42 years old when she died from pneumonia. Unfortunately, information about her short life is scant, but we do know that she made some 800 photographs, 775 of which are now in the care of the Victoria and Albert Museum in London. Her work was also extremely well-regarded in her lifetime. 'The photography scene at this point in history was dominated by males so for a female to achieve the amount of recognition she did in such a short space of time was a tremendous achievement', says Francesca Spickernell, photography specialist at Bonhams. 'Most photography was very masculine and mostly architectural so these elegant, feminine shots really stood out.'

ELEVATE YOUR PORTRAITS USING DAYLIGHT AND A MIRROR

Working in a naturally lit room, ideally close to a window, position a mirror (it can be full-length, but it doesn't have to be) at an angle to your subject. Dress the space with throws or other pieces of material and bring in a chair and cushions to add interest.

With your camera on a tripod, play with the position of your subject in relation to the window and mirror. A key part of the composition is the balance between the person and their reflection, so take time to get this right. Tweak the position of your subject and props until you have a good balance across the frame.

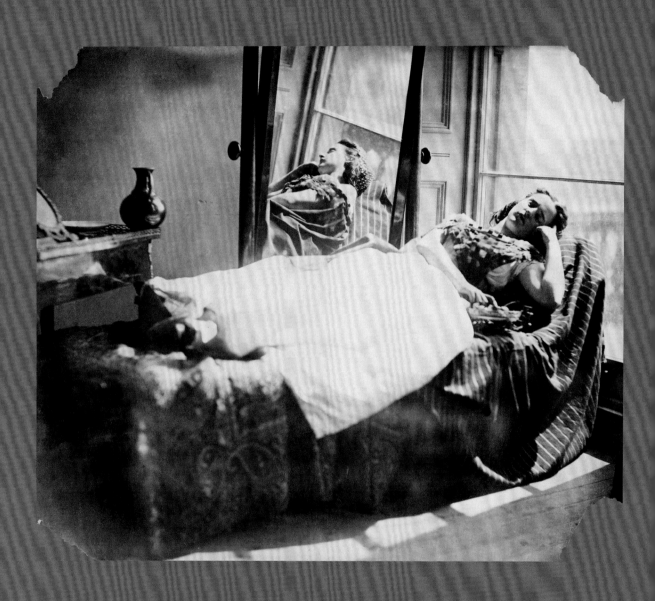

*Woman Having an Afternoon
Sleep*, Lady Clementina
Hawarden, c. 1860

DAFNA

British
Born 1974
Art
Landscape

THE LANDSCAPE CREATOR

'Photographic truth' is a slippery concept, one that has long been a source of fascination and inspiration for artists and photographers. Dafna Talmor works within this ambiguous space. Tiptoeing along the edges between the imaginary and the actual, she invites viewers to enter spaces that look real but are, in fact, fabricated. Based in London, Talmor works with cut negatives – initially using images of locations that have special personal significance – to make 'constructed landscapes'. Pieces are carefully reassembled to form landscapes that exist only in the newly created images.

Born in Israel and raised in Venezuela, Talmor moved to the UK in the late 1990s to study at Goldsmiths in London and then at the Royal College of Art. Interested in the idea of 'home' and transnational identity, her early images of interior spaces often hinted at what existed beyond her four walls. When she did venture outside with her camera, she often felt overwhelmed, Talmor says, because there were no longer any clear boundaries within which to photograph. Compelled nonetheless to record the landscapes she encountered – out of a personal need to take a place with her, to create 'keepsakes' – of where she grew up, where her family lives or the UK which she now calls home, Talmor amassed a huge archive of colour negatives, which she boxed away, unsure what to do with them.

In 2009, having spent time going through contact sheets, Talmor found that one way to make use of the images was to make interventions directly on to the negatives, which became her source material. Working intuitively, she found herself removing obvious human-made elements – roads, structures, bridges – which disrupted the landscape in some way. The resulting gaps or apparently 'blank' spaces can in fact be read as forms and become an integral part of each newly created image. Her process is both serendipitous and considered, says Talmor, and she embraces mishaps or imperfections that happen along the way.

On one level, Talmor's work harks back to early pictorialist techniques of combination printing by photographers such as Gustave Le Gray and Oscar Gustave Rejlander. This approach involved photographing, for example, the sky and sea separately and then combining them in the darkroom to make a single (constructed) idealized image. While pictorialists who worked in this way wanted to conceal the manipulation that had taken place, for Talmor the opposite is true: she intends for the joins to be visible, for the viewer to see that what they are looking at has been constructed. She wants the images to be 'relatable' in some way, as well as disorientating. Although anchored in reality, the images are also a kind of idyll or utopia – images that only exist in a fiction. The work also nods to modernist experiments where artists interfered with the film or created multiple exposures. It draws attention to the handmade, to manual intervention in an age of immateriality and digital manipulation. Hopefully, the work shows that there are multiple truths, says Talmor [60], whose work is held in major public collections such as the V&A. There are many ways of interpreting a landscape, or indeed any photographic image, and that is both the joy and perplexing nature of photography.

CUT AND REASSEMBLE YOUR IMAGES TO MAKE ATMOSPHERIC PHOTOCOLLAGES

Dafna Talmor works with cut negatives, but you don't have to shoot on film to try her technique.

Make prints of your digital images, cut them up and reassemble the pieces to form new images. Think carefully about where you make incisions and where you want the joins to be to create a composition that is both cohesive and varied. You could re-photograph and print out the result to give a physical artwork.

Untitled (MU-1818181818-1) from
'Constructed Landscapes (Vol. II)',
Dafna Talmor, 2019

BARBARA

American
1900–1992
Art
Dance
Mixed media

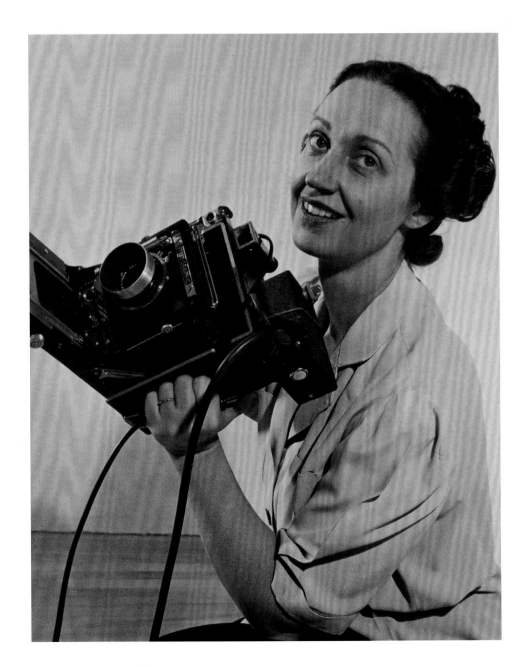

THE DANCE DOYENNE

Experimental, creative and curious, Barbara Morgan is best known for her hypnotic photographs of dancers, most famously the American modern dancer and choreographer, Martha Graham. Like the sinuous bodies of her images, Morgan's way into and through photography is a fascinating one with many twists and turns. Born in Buffalo, Kansas, Morgan trained as a painter and taught at the University of California, Los Angeles. While installing an exhibition of photographs at the university gallery by a (then) not very well-known photographer called Edward Weston, Morgan asked the young photographer what he was trying to do in his photographs. He replied: 'I'm trying to portray essence.' The comment had an impact on Morgan. She remembers looking at Weston's photographs with their mesmerizing curves and thinking: 'If I ever photograph, my [subjects] have got to move.' [61]

Morgan's husband, Willard, who was a photographer and, later, a publisher, encouraged her to pick up a camera and give photography a go. Morgan never formally studied to be a photographer but her husband had set up a darkroom in the couple's bathroom and every time she went in, she learnt something new. Every summer, they would travel to the Southwest where Morgan would assist her husband with his picture-making, often helping to fine-tune his compositions. Willard taught her about photographic technique and, during these trips, Morgan's interest in photography continued to gather pace.

In 1930, the couple relocated to New York. By 1935, with two young sons, there was less opportunity and time for Morgan to paint. Photography was quicker to do. Acutely aware of the fallout from the economic crisis on the everyday lives of New Yorkers, and inspired by constructivism, Morgan made photomontages as a form of social commentary, piecing together fragments of prints or combining multiple negatives on an enlarger.

But it was her introduction to Graham in 1935 that sent her career spinning off in an exciting new direction. Present at rehearsals attended by Graham and other company members, Morgan would study the way the dancers moved and the interplay of light. Deeply aware of 'the emotional impact that timing makes' [62], she made tests at different shutter speeds to see what impact these studies had on the way the camera rendered the dancers' movement and their swishing clothes.

Her best images are sculptural, shot through with energy, their sense of rhythm palpable. Morgan's interest in the fragmentation of the body is most apparent in her dynamic multiple-exposure images. She did light painting too and made abstract photograms. Co-founder of the photographic magazine *Aperture* in 1952, a publication that encourages discussions around photography as art, Morgan left behind a body of work that effortlessly captures and celebrates the joyous dynamism of movement of people, of energy and of life itself.

CREATE AN ABSTRACT IMAGE USING
MULTIPLE EXPOSURES

When photographing Martha Graham, Morgan
sometimes exposed several images on a single
negative to give a sense of the dancer's movement.

If you are using a digital single-lens reflex (DSLR)
camera, check to see if it has a dedicated 'Multiple
Exposure' mode – most modern DSLR cameras
should have one. Set your camera to this mode
and attach your camera to a tripod to keep it in
one place and allow movement to happen around it.
For a more advanced approach, use a slow exposure
of several seconds and manually trigger your flash
multiple times while the shutter is open.

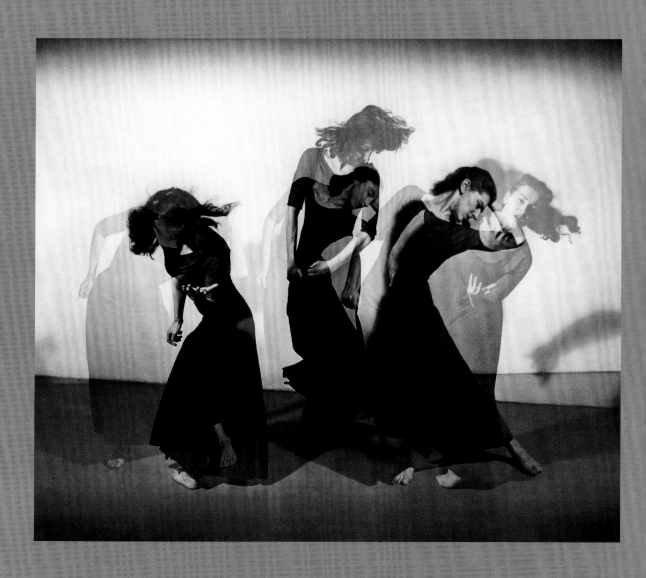

Martha Graham, American Document
Trio, Barbara Morgan, 1938

MAUD

Scottish Ghanaian
1960–2008
Art
Mixed media
Portraiture

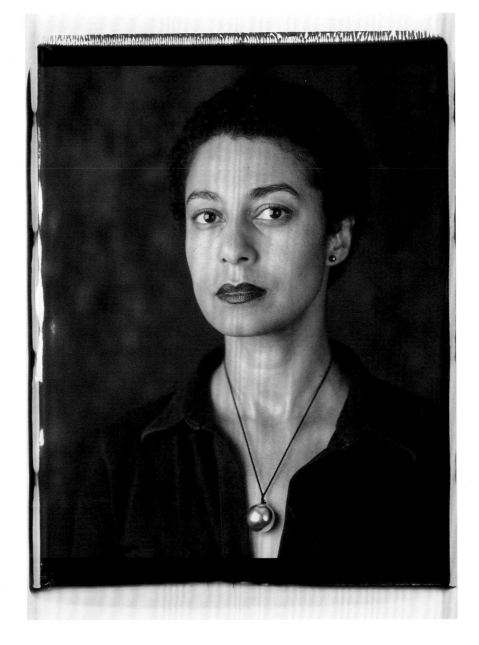

THE POLYMATH

She made it her life's work to 'put Black women back in the centre of the frame' [63]. Scottish-Ghanaian artist and writer Maud Sulter did this quite literally in terms of the photographic image, but she also sought to address the profound lack of representation in galleries and museums of which she was highly critical.

Born in Glasgow, Sulter initially poured her creative energy into writing poems, achieving critical acclaim in the mid-1980s. A true polymath (she was also a lecturer, publisher, curator and gallerist), Sulter became enamoured with exploring how poetry and photography could be combined in creative ways, an interest that continued throughout her career. The mixing of words and images can be seen in works such as 'Zabat' (1989), the series to which the image on page 186 belongs. Comprising prose poems and nine large-scale allegorical portraits, the work features Black women who embody various muses of art and science in Greek mythology. Sulter herself plays Calliope, the muse of epic poetry. The series' title, according to Sulter, refers to an ancient sacred dance. Multi-layered, the series, which was commissioned by Rochdale Art Gallery on the 150th anniversary of the invention of photography, can be interpreted in multiple ways. By placing the figure of a Black woman front and centre, Sulter cleverly subverts traditional Western historical art where the subjects are almost always white. From the prominent heavy gold frames, a mainstay in Western historical painting, to the inclusion of objects that were painted into works of art to provide clues about the sitter's character, the artworks are rich in symbolism. They also reflect Sulter's preoccupation with absence and presence regarding Black figures in cultural histories. For example, as well as playing a Greek muse in the pictured image, Sulter poses as Jeanne Duval, who was the Haitian muse, model and mistress of the French poet/critic/author, Charles Baudelaire. Sulter became interested in Duval after seeing a daguerrotype of her by the renowned 19th-century photographer Nadar, titled *Femme Inconnue* or *Unknown Woman*. By impersonating Duval, about whom little is known, Sulter makes a direct comment on the way Black people are written into (or out of) history. Indeed, as Sulter noted, the series was made 'to raise questions around Black presence in art galleries' [64]. Duval remained a source of fascination for Sulter, who went on to create a series of portraits of herself posing as the model [65].

A Feminist campaigner and member of the Black British Arts Movement, Sulter, who studied a master's in photographic studies at the University of Derby in 1990, was committed to exploring art's role in the world and making histories visible. Through her work, which also includes photocollage, she explored the experiences of the African diaspora in European history and culture, tirelessly working to bring Black marginalized women to the fore. Sulter died from cancer at the age of 47, leaving behind a valuable body of work that has played an important role in the reappraisal of art histories.

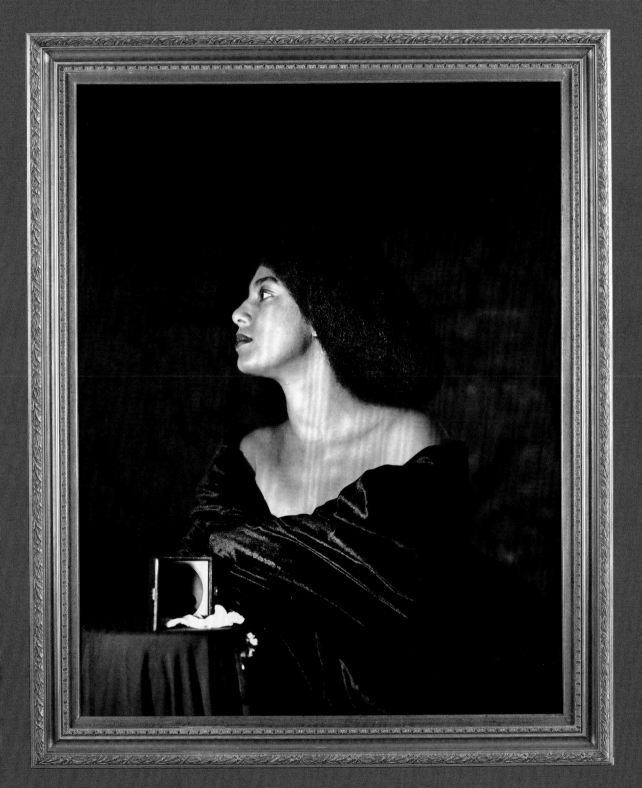

CRAFT A PORTRAIT OF SOMEONE YOU ADMIRE

Is there someone you think should be celebrated in a photographic portrait? You could either dress up as that person in a self-portrait, or photograph the person directly, using props, clothing and a backdrop to tell the viewer something about their life.

Think about the message you want the portrait to convey – is there an important issue to which that person is linked that you could explore through the way you compose your image? Could symbolism play a role in conveying that message?

Calliope, Maud Sulter, 1989

LAIA ABRIL

Catalan
Born 1986
Art
Documentary
Mixed media

THE RESEARCHER

Laia Abril is an artist whose research-driven work engages with difficult and often hidden topics head on, including issues and lived experiences relating to abortion, gender equality, eating disorders and sexuality. Working with photography, text, video and sound, and utilizing the exhibition space, book format and digital platforms to present her work, the Catalan artist uses whatever means she feels is necessary to tell a story in the most faithful and engaging way possible.

Often working on projects over years and in multiple instalments or chapters, Abril's first long-term body of work was an investigation into eating disorders which examined individual complex threads, including the struggles of a girl with bulimia and the pro-anorexic community. The highly acclaimed 'A History of Misogyny', for which Abril is arguably best known, followed. A multi-chapter epic, the project takes a deep dive into the systemic, cross-cultural control and abuse of women's bodies that has occurred historically, as well as in contemporary societies. 'I'm trying to visualise what you can't see,' Abril has said of her work, which is both journalistic and artistic in approach [66]. Although she deals in facts born of intensive research, Abril works hard to find conceptual ways of presenting her findings to draw attention to an issue and, in turn, draw in the viewer. It is not her intention to tell viewers what they should think. Rather, she invites them to make up their own minds about what they are seeing.

Born in Barcelona, Abril graduated with a degree in journalism before moving to New York to study photography at the International Center of Photography. It was during this time that she became interested in stories that went under the radar – areas of life that were not typically reported by mainstream news outlets. The lack of visibility spurred her on, giving her the courage to travel, figuratively speaking, to uncomfortable places. In 2009, Abril joined the prestigious artist residency programme at Fabrica, the Benetton research centre in Treviso, Italy, and went on to work as a researcher, photo editor and staff photographer at the culturally progressive *Colors* magazine produced by Fabrica.

When Abril returned to Barcelona via New York, her work on 'A History of Misogyny' began in earnest. Combining images and text, the project's first chapter, 'On Abortion' (2016), investigates the repercussions of lack of access to safe, legal and free abortions in various communities around the world, and raises complex and controversial ethical and moral questions. Many of the images, which include portraits and still lifes, as well as documentary-style images, are reconstructions, while the text – including subject statements and factual texts by Abril – plays an integral contextualizing and influencing role in the overall narrative. A second chapter, 'On Rape: And Institutional Failure', followed, and a third chapter, 'Mass Hysteria' (2023). An artist who occupies, and has made entirely her own, a unique hybrid space between photojournalism and art, Abril produces work that is informative, urgent, expressive and deeply affecting. In her hands, photography, design and text come together to form work that offers vital insights into areas of life that are often ignored.

USE OBJECTS TO TELL A STORY ABOUT SOMETHING THAT MATTERS TO YOU

In 'A History of Misogyny, Chapter One: On Abortion and the Repercussions of Lack of Access', Laia Abril includes carefully arranged still-life images featuring various artefacts: namely, rudimentary contraceptive devices and surgical instruments used in abortion. Using a conceptual approach, Abril conveys ideas in a way that is sophisticated and effective.

Is there a topic that matters to you which you could investigate through still-life imagery? Think about the objects you could use in your composition and how they could be arranged for maximum impact. Try attaching your camera to a tripod and capturing the scene from above to create bold, graphic images.

Illegal Instrument Kit from 'On Abortion', Laia Abril, 2016

ZANELE

South African
Born 1972
Art
Documentary
Portraiture

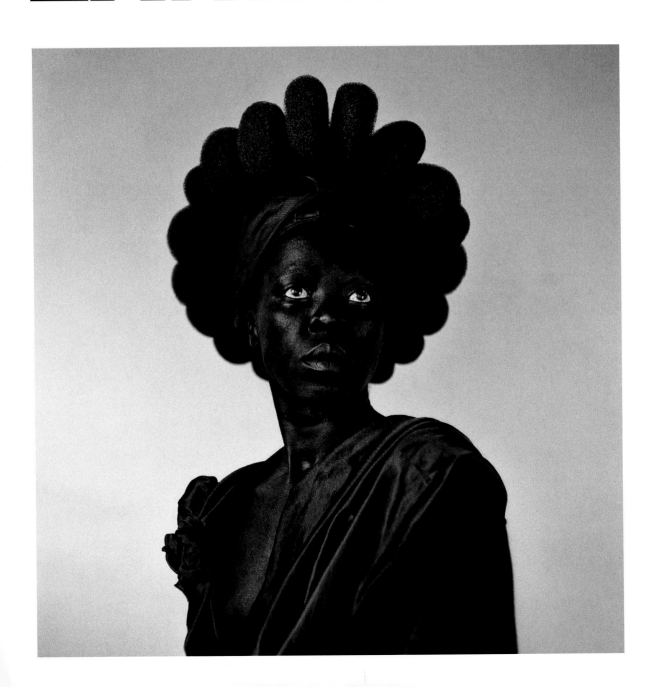

THE LGBTQIA+ CHAMPION

A highly respected photographer, Zanele Muholi is a visual activist and artist who has dedicated their life to documenting and celebrating the LGBTQIA+ community in their home country of South Africa. Through documentary photography and portraiture, but also film, Muholi, who was born in Umlazi, Durban, explores issues around race, discrimination, identity, visibility, equity, queerness and representation, empowering the 'participants' (as Muholi calls their subjects) and queer Black communities across South Africa and beyond.

Since the early 2000s, Muholi, who identifies as non-binary, has put Black lesbian, gay, trans, queer and intersex communities front and centre in their work, producing powerful portraits and intimate, moving documentary images that demand their subjects are seen. Muholi's aim is to create awareness, they have said, and to reinstate people from these communities into the canon from which they have been excluded.

For Muholi, the fight is as much a collective, community-driven effort as it is a personal mission. 'We want to bring about change in spaces that are queer-phobic,' they have said. 'It's about the need to document realities of people who deserve to be heard, who deserve to be seen.' [67] Muholi also runs photography workshops with young people, giving them cameras and encouraging them to document their own lives.

One of Muholi's earliest bodies of work, which they started in 2006 and which is ongoing, is 'Faces and Phases', a collection of hundreds of portraits of Black lesbian, gender-nonconforming, bi and trans people. Muholi began the project in response to the discrimination and violence perpetrated against LGBTQIA+ communities. The work is 'about us being counted in South African visual history,' says Muholi. 'I think that's true photography – to say that you were present.' [68]

Photographed predominantly with each participant's head and shoulders clearly visible in the frame, the images employ a deliberately bold, yet deceptively simple, approach. Muholi's participants look straight at the viewer, returning their gaze. Sometimes they face the camera squarely. At other times, they turn slightly away. But in every portrait, Muholi pulls us into that person's space and we disappear into their world. Little is known about the people in these images, and Muholi does not give much away. Yet Muholi's portraits are full and rich and profound. They enthral and excite in equal measure.

The artist has also put themselves in the frame in the more recent series, 'Somnyama Ngonyama (Hail, the Dark Lioness)'. As in their portraits of others, Muholi confidently meets our gaze. 'I want people to understand our existence and presence, to say, "we exist",' says Muholi. 'Photography has given me that space to express the self in ways that I would not have been able to if I used another medium.' [69]

MAKE A PORTRAIT WHERE YOUR SUBJECT LOOKS DIRECTLY INTO THE CAMERA

One way to create a powerful portrait is to have your subject look straight into the lens. This bold approach delivers impact because the person is confronting the camera and, in turn, the viewer.

Find a location with a background that is interesting without being distracting. Place your light source slightly above and directly behind the camera. Position the person you are photographing in the centre of the frame and ask them to stand at a three-quarter angle. Get them to turn their head towards the camera. Using a fairly shallow depth of field (an aperture wider than f/8) and a shutter speed of at least 1/200th second, make an exposure. Prime lenses with a focal length of 50mm to 100mm are ideal. A longer focal length will allow you to bring the background closer to your subject. If you have a zoom lens, for example, a 70–200mm, try shooting at a few different focal lengths and compare results.

Xana Nyilenda, Newtown, Johannesburg from 'Faces and Phases', Zanele Muholi, 2011

LORNA

American
Born 1960
Art
Mixed media
Portraiture

THE ECLECTICIST

Lorna Simpson is a multidisciplinary artist whose practice includes photography, found photographs, drawing, painting, video installation, sculpture and collage. Anything can be a source of inspiration, including popular culture, music, sports, entertainment and the art world [70], says Simpson. 'I think all of it, for me, is ... an influence, beckoning me to ... steal or admire.'

Living and working in Brooklyn, New York City, where she was born and grew up, Simpson explores numerous themes, including the nature of representation, memory, identity, sexual desire and society's relationship to race and gender with an emphasis on African American women. She is best known for her photo-text works and photocollages comprising cuttings from vintage *Jet* and *Ebony* magazines from the 1930s to the 1970s, juxtaposed in striking ways, but Simpson has also overlaid photographs with ink and acrylic, made silkscreen prints on felt and experimented with audio. Investigating representations of Black women in American culture and society, Simpson excavates and analyzes gesture and pose with a forensic touch. By fragmenting the figures in her works, often cropping out parts of a subject's body, Simpson draws attention to the 'depersonalization' of Black bodies throughout history. [71]

After studying photography at the School of Visual Arts in New York, Simpson received a master's in visual arts from the University of California, San Diego, in 1985. Having spent time making documentary photographs, she began to question photography's limitations and the way photographs are typically 'read' – how 'we look at photography and look for meaning' [72] – and their legitimacy as vehicles for truth. Seeking new ways to engage with the medium and, in turn, connect with an audience, Simpson began playing with text, superimposing words (her own) over studio-style posed portraits – or 'anti-portraits' – of African American women whose faces were obscured or who had turned away from the camera. In these early performative works, Simpson disrupts preconceived notions of how to 'read' a photograph and in doing so throws the possibility for multiple meanings or readings wide open, something she has done time and again in her enigmatic works.

While not the first female artist to work with text in a conceptual way, (artists Jenny Holzer and Martha Rosler were already making a name for themselves in this arena), Simpson took the photo-text approach in a new direction in the way she used it to raise questions about perceptions of African American women. In 1990, Simpson became the first African American woman to exhibit at the Venice Biennale international arts festival. She had a solo exhibition at the Museum of Modern Art that same year. From the 1990s onwards, Simpson began working with video and film, and in the 2010s created her celebrated photo collages.

Through her quietly compelling, multifaceted work, Simpson weaves complex, open-ended narratives that spark difficult questions about the formation of biases and the part that photography and other media play in both maintaining those biases, but also – encouragingly – in the construction of new perspectives.

PHOTOGRAPH YOUR SUBJECT FROM BEHIND

Photographing a subject from behind and in turn defying the viewer's gaze is an approach Simpson has often used. By having her subjects turn away from the camera, and in doing so concealing their faces and expressions, Simpson creates a sense of agency – these people refuse to be visually consumed. Simpson reinforces this message in *Partition and Time*, 1991 (pictured), where the image of a woman is duplicated and reversed.

Try photographing your subject against a simple backdrop with their back to the camera, using a single overhead light to add impact. Play around with how much of the figure is shown by coming in close or pulling back.

20%
1 out of 3
1 in ten
3 out of 4
one fifth
10%
75%
100%
50%

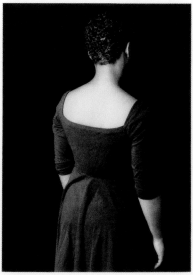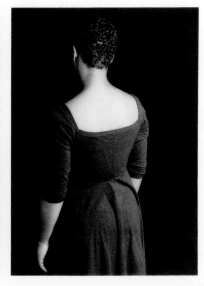

intermittent
daily
slow
for the time being
nightly
up to now
against
in the meantime
weekly
fast
throughout
spend
constant

Partitions and Time,
Lorna Simpson, 1991

VIVIAN

American
1926–2009
Documentary
Portraiture
Street

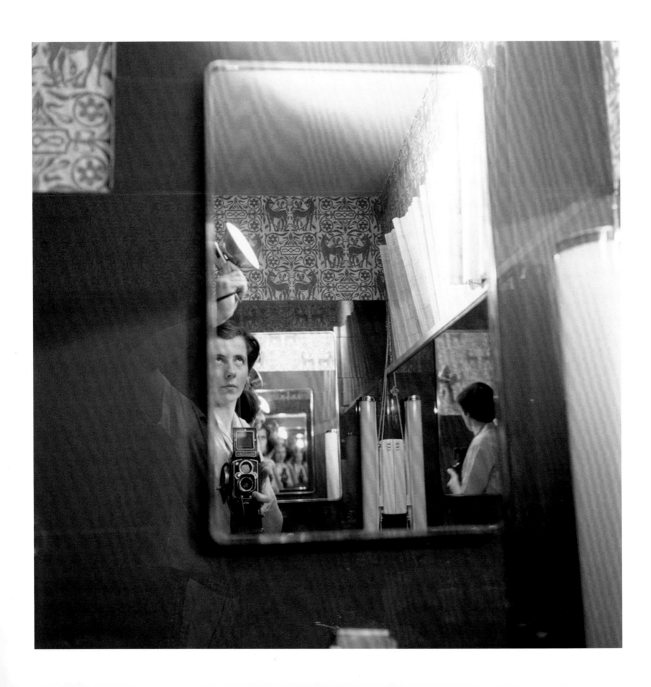

THE ELUSIVE STREET PHOTOGRAPHER

Until Vivian Maier's vast archive was discovered in 2007 and shared with the world online two years later, barely anyone knew who she was. Today, Maier is one of the most famous street photographers ever to have lived. But despite her posthumous fame, she remains a mysterious, enigmatic figure.

The story of this most reclusive and eccentric of photographers is one of intrigue and surprise. Indeed, it is entirely by chance that Maier and her work became known at all. The unravelling of her story began after John Maloof, a local-history enthusiast in Chicago, purchased a box of negatives at auction. No one knew who had taken the images, but Maloof decided to investigate. The images turned out to be by Maier, a local nanny who was also a secret amateur photographer. Sourcing more of her work, Maloof amassed a collection of more than 100,000 negatives, several thousand prints and hundreds of rolls of film, as well as videos, audio interviews and other personal effects. He went on to make the Oscar-nominated film, *Finding Vivian Maier* (2013), and manages the largest collection of her work. Thanks to his diligent efforts, and others, Maier's name has been etched into histories of photography.

For decades, from the early 1950s onwards, Maier, who was born in Manhattan to a French mother and an Austrian father, photographed on the streets of New York, Chicago and Los Angeles. Her subjects were principally the people she encountered locally, sometimes photographed unawares and other times not. Children frequently feature, as do bold shop fronts, throngs of people, intimate moments between couples and any number of small dramas writ large by Maier. Self-portraits in mirrors or windows were another favourite subject.

Maier had taken up photography at the end of the 1940s while in the French Alps and initially used a Kodak Box Brownie before switching to a Rolleiflex. Its waist-level viewfinder provided the perfect means to photograph in a less noticeable way.

Maier never exhibited her images while she was alive. In fact, she did the opposite, keeping her archive hidden away. It is not known what drove Maier to make the photographs she did or why she chose not to work professionally, but what is clear, given how prolific she was, is her passion for photography and apparently insatiable desire to record the world as she experienced it. Her archive provides a fascinating insight into mid-20th-century American street life, the best of it up there with the likes of Garry Winogrand, Lee Friedlander and Joel Meyerowitz, three of photography's greatest street photographers. But her importance in the history of photography is not only due to the work: Maier is a pioneering figure in photography because she was doing something that few women were doing at the time, let alone with such fervour.

COMBINE COLOUR, SHADOWS AND FORM
IN YOUR STREET PHOTOGRAPHS

Vivian Maier is best known for her black-and-white street photographs, but she also used colour film, often producing images that are striking precisely because of her decision to use colour. Here, Maier has photographed through some kind of awning or screen. It's not only the colour that makes the image, but the way Maier has shot into the light and used the children's silhouettes to shape her composition.

Go out onto a street and switch the dial in your head to tune into colour. Learning to see colour and understand what colour combinations work takes practice. Look for bold, contrasting colours and opportunities to bring shadows into the mix.

Untitled, Vivian Maier, Undated

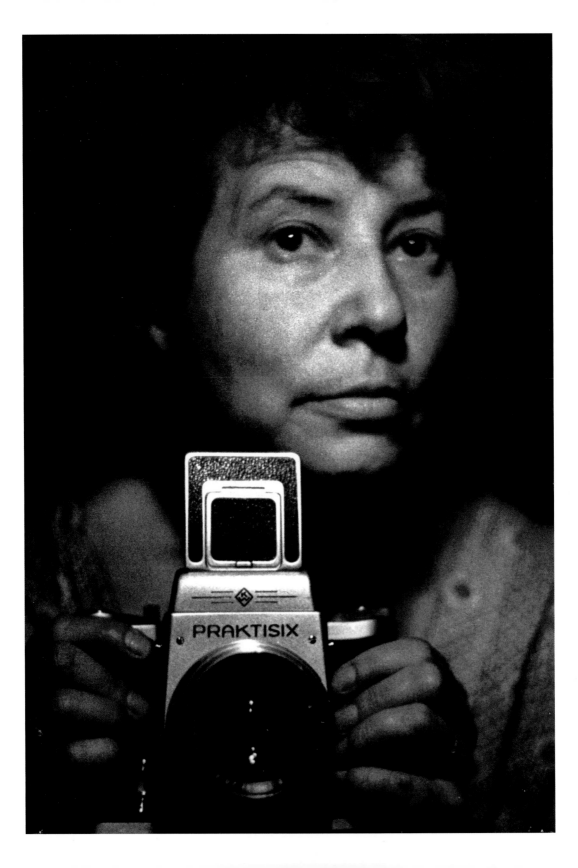

ZOFIA RYDET

Polish
1911–1997
Art
Documentary
Portraiture

THE CATALOGUER

So much of photography is to do with making a connection with your subject. And so it was for Zofia Rydet, the Polish photographer best known for her immense and ambitious body of work, 'Sociological Record'. In 1978, when she was 67 years old, Rydet, who was born in the Polish town of Stanisławów, now Ivano-Frankivsk in Ukraine, set herself the task of photographing every household in her home country. Her approach was simple: she would knock on a door, say hello and compliment the occupants on something in their home that caught her eye. Upon winning the occupants' trust, she photographed them using the interior as a backdrop. Creating images in this way, with what she called 'great consistency' [73], brought Rydet a huge amount of satisfaction, she once remarked.

Rydet, a self-taught photographer, had long been interested in people – in aspects of the human condition – having begun her photography career in the 1950s with a project about childhood. The idea for 'Sociological Record', which would occupy her for the rest of her life, came to Rydet after she noticed intricate, but distinct, differences between workers' otherwise identical office spaces. Each one, she noted, had been personalized by its inhabitant and was therefore completely unique. Profoundly moved by these actions and intrigued by what they revealed about human behaviour, she decided to embark on a project that explored what people's possessions said about them – how their personal spaces reflected them as individuals. She visited more than 100 villages and towns in Poland and further afield, including in France, Lithuania and Germany.

The unfinished project, which Rydet realized she would never be able to complete, reveals an almost obsessive desire to catalogue, to create groups. The project evolved into thematic subcategories that included women outside their homes and photographs featuring photographs. Each image appears to be a simple visual record – an almost unremarkable documentary photograph. But, look closely and details gradually reveal themselves – photographs and tapestries hang on walls, there is religious iconography and domestic paraphernalia. Each image is a glimpse of a life lived and, at that point in time, still to be lived.

Rydet created a unique archive of time and place, depicting life as it was experienced by ordinary folk in communist-era Poland – a way of life that was beginning to slip away. Rydet was aware of the impact that modernization was having on local communities and made it her mission to document those communities before it was too late. But the work is much more than a straightforward document of a disappearing way of life: it says much about photography itself or, rather, what Rydet believed photography could do: arrest time and defy death. Rydet had strong views on photography, which she saw principally as a language, a vehicle for information, a means to draw attention to something that might otherwise be overlooked. She once said: 'I'm not after some "great artistic expression". I want to move people a bit, to make them reflect.' [74]

MAKE INTIMATE ENVIRONMENTAL PORTRAITS
USING A WIDE-ANGLE LENS AND FLASH

When making 'Sociological Record', Zofia Rydet
mostly used the same distinct photographic
approach. Usually having her subjects face the
camera, she used a wide-angle lens and a flash to
illuminate the person or people's surroundings.
For Rydet, what was in the room was as important
as the person or people she was photographing.

Try photographing a family member or friend in
their home environment using a wide-angle lens and
with your camera set to the correct sync speed for
flash (usually 1/125th second). Start with your flash
gun on top of the camera for a direct lighting look
or, if you have a remote trigger, try positioning your
flash to one side of your camera. If you are shooting
digitally, convert your images to black and white and
experiment with the contrast controls to add impact.

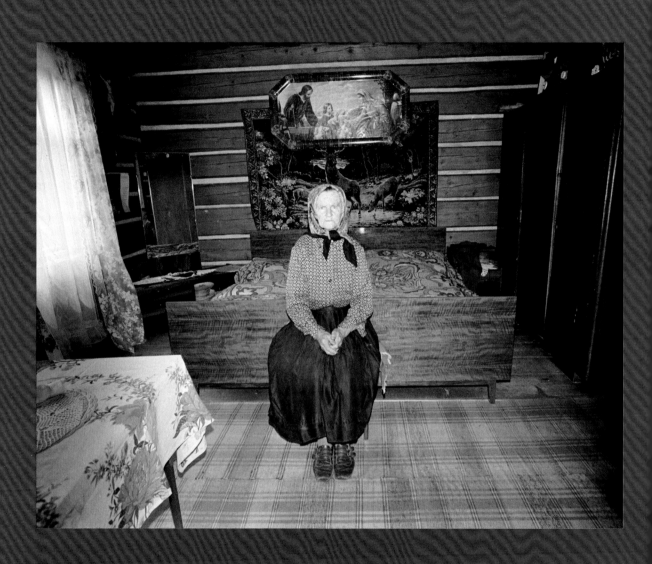

From 'Sociological Record',
Zofia Rydet, 1979

Books

Bouveresse, Clara. *Women Photographers: Pioneers*, Thames & Hudson (2020)

Bouveresse, Clara. *Women Photographers: Revolutionaries*, Thames & Hudson (2020)

Bouveresse, Clara. *Women Photographers: Contemporaries*, Thames & Hudson (2020)

Friedewald, Boris. *Women Photographers: From Julia Margaret Cameron to Cindy Sherman*, Prestel (2018)

Jansen, Charlotte. *Girl on Girl: Art and Photography in the Age of the Female Gaze*, Laurence King Publishing (2019)

Lebart, Luce and Robert, Marie. *A World History of Women Photographers*, Thames & Hudson (2022)

Lewis, Emma. *Photography – A Feminist History*, Ilex Press (2021)

Nelson, Andrea. *The New Woman Behind the Camera*, DelMonico Books/ D.A.P. (2020)

Raymond, Claire. *Women Photographers and Feminist Aesthetics*, Routledge (2017)

Rogers, Fiona and Houghton, Max. *Firecrackers: Female Photographers Now*, Thames & Hudson (2017)

Rosenblum, Naomi. *A History of Women Photographers*, Abbeville Press (1994)

Williams, Val. *The Other Observers: Women Photographers in Britain 1900 to the Present*, Virago (1986)

Zalcman, Daniella and Ickow, Sara. *Women Photograph: What We See: Women and Nonbinary Perspectives Through the Lens*, White Lion Publishing (2023)

Websites and Organizations

AWARE: Archives of Women Artists, Research and Exhibitions
awarewomenartists.com

Fast Forward: Women in Photography
fastforward.photography

Firecracker
fire-cracker.org

Hundred Heroines
hundredheroines.org

The Parasol Foundation Women in Photography project at the V&A
vam.ac.uk/blog/museum-life/the-parasol-foundation-women-in-photography-project

Women Photograph
womenphotograph.com

Women Photographers International Archive (WOPHA)
wopha.org

SOURCES

1 https://www.youtube.com/watch?v=1MJHFvM9LfY (Accessed 13 July 2023) Haley, J., 2021. *Women and Photography in the Nineteenth Century*, Canterbury Museum

2 Lebart, L., Robert, M., 2022. *A World History of Women Photographers*, Thames & Hudson

3 Lebart, L., Robert, M., 2022. *A World History of Women Photographers*, Thames & Hudson

4 https://www.vivianesassen.com/works/heliotrope/ (Accessed 5 June 2023)

5 https://www.theguardian.com/fashion/2013/oct/12/fashion-photographer-viviane-sassen (Accessed 5 June 2023)

6 https://www.theguardian.com/fashion/2013/oct/12/fashion-photographer-viviane-sassen (Accessed 5 June 2023)

7 https://i-d.vice.com/en/article/j587y7/liz-johnson-arturs-photos-celebrate-black-communities-black-aesthetics-and-black-creativity (Accessed 17 July 2023)

8 https://www.tate.org.uk/visit/tate-modern/display/artist-and-society/liz-johnson-artur (Accessed 17 July 2023)

9 https://bristolphotofestival.org/lips-touched-with-blood-sarah-waiswa/ (Accessed 5 June 2023)

10 https://www.youtube.com/watch?v=xm_J9YyFU90 (Accessed 5 June 2023)

11 https://conversations.e-flux.com/t/homai-vyarawalla-a-portrait-of-a-groundbreaking-photographer/6988 (Accessed 5 June 2023)

12 https://hundredheroines.org/historical-heroines/alice-austen/

13 Author interview conducted via email between 31 May 2023 and 7 June 2023

14 https://www.nytimes.com/1986/02/23/arts/camera-pioneer-aluted-at-icp.html (Accessed 5 June 2023)

15 https://www.moma.org/artists/561 (Accessed 5 June 2023)

16 https://www.foam.org/podcasts/speaking-nearby-rahima-gambo-aziza-harmel (Accessed 5 June 2023)

17 https://web.archive.org/web/20140722150917/http://www.artnewsnviews.com/view-article.php?article=towards-cutting-edge-art-definitive-attempts&iid=28&articleid=750 (Accessed 10 May 2023)

18 Lewis, E., 2021. *Photography – A Feminist History*, Ilex Press

19 https://www.moma.org/artists/2595 (Accessed 8 May 2023)

20 https://www.vogue.co.uk/article/dua-lipa-january-cover-future-issue-british-vogue-2019 (Accessed 10 March 2023)

21 https://www.bbc.co.uk/sounds/play/w3cswp2j (Accessed 10 July 2023)

22 https://www.cntraveler.com/story/how-i-became-a-photojournalist-lynsey-addario-on-life-on-the-road (Accessed 10 July 2023)

23 https://www.bbc.co.uk/sounds/play/w3cswp2j (Accessed 10 July 2023)

24 https://archive.nytimes.com/lens.blogs.nytimes.com/2011/03/30/lynsey-addario-its-what-i-do/ (Accessed 10 July 2023)

25 http://www.luminous-lint.com/app/photographer/Catharine_Weed__Barnes/A/ (Accessed 3 April 2023) Weed Barnes Ward, C., 1889. 'Photography From a Woman's Standpoint' in *The Photographic Times and American Photographer*, 27 December, 1889, Vol. XIX, No.432, pp652–3

26 Author interview, *IMA* magazine, vol.16, 'How They Are Made', 2019

27 https://nmwa.org/blog/5-fast-facts/5-fast-facts-lola-alvarez-bravo/ (Accessed 18 July 2023)

28 https://artmuseum.mtholyoke.edu/sites/default/files/Beautiful_Physics_Photographs_by_Berenice_Abbott.pdf?bc=node (Accessed 14 June 2023) Smith, S., *Beautiful Physics: Photographs by Berenice Abbott,* Mount Holyoke College

29 Mitchell, M. K., 1979. *Recollections: Ten Women of Photography*, NY: Viking Press

30 Tate film, https://www.youtube.com/watch?v=EFGJOwVUGTA (Accessed 19 June 2023)

31 Tate film, https://www.youtube.com/watch?v=EFGJOwVUGTA (Accessed 19 June 2023)

32 https://www.1854.photography/2021/12/any-answers-ingrid-pollard/ (Accessed 19 June 2023)

33 Pyne, K., 2020. *Anne Brigman: The Photographer of Enchantment*, New Haven and London: Yale University Press

34 Paris Photo, https://www.youtube.com/watch?v=5ffFbGEFa6M (Accessed 16 May 2023)

35 https://www.iwmf.org/our-awards/reporting-from-the-front-lines-of-war-an-interview-with-anja-niedringhaus-and-kathy-gannon/

36 www.dw.com/en/an-eye-for-dignity-war-photographer-anja-niedringhaus/a-37111599 (Accessed 1 March 2023) Mund, H., 2017. *An eye for dignity: War photographer Anja Niedringhaus,* Deutsche Welle (DW)

37 https://dartcenter.org/content/remembering-anja-niedringhaus (Accessed 1 March 2023)

38 https://time.com/4764211/anja-niedringhaus-legacy (Accessed 1 March 2023)

39 https://www.bbc.com/culture/article/20190328-paz-errzuriz-the-woman-who-defied-the-pinochet-regime (Accessed 12 May 2023)

40 https://lareviewofbooks.org/av/photographer-spotlight-marginals-majority-michael-kurcfeld-paz-errazuriz-video/ (Accessed 12 May 2023)

41 https://www.getty.edu/art/exhibitions/
sally_mann/inner.html (Accessed 29 May 2023)

42 https://www.magnumphotos.com/arts-
culture/fashion/eve-arnold-fashion-in-harlem/
(Accessed 29 May 2023) Abel-Hirsch, H., 2017.,
'Harlem Fashion', Magnum Photos

43 https://www.magnumphotos.com/arts-
culture/society-arts-culture/eve-arnold-the-
unretouched-woman/ (Accessed 29 May 2023)
Arnold, E., 1976. *The Unretouched Woman*,
New York: A.A. Knopf Cape (Excerpt.)

44 https://www.magnumphotos.com/arts-
culture/society-arts-culture/eve-arnold-the-
unretouched-woman/ (Accessed 29 May 2023)
Arnold, E., 1976. *The Unretouched Woman*,
New York: A.A. Knopf Cape (Excerpt.)

45 Lebart, L., Robert, M., 2022. *A World History
of Women Photographers*, Thames & Hudson

46 https://www.moma.org/artists/7851
(Accessed 22 March 2023)

47 https://chroniclingamerica.loc.gov/lccn/
sn88064339/1897-12-04/ed-1/seq-7/
(Accessed 22 March 2023)

48 https://www.youtube.com/watch?
v=M43QgkbOEv8 (Accessed 12 May 2023)

49 https://www.magnumphotos.com/theory-
and-practice/susan-meiselas-work-ethic/
(Accessed 28 June 2023)

50 https://www.ft.com/content/
4f15e162-e4a5-11e9-9743-db5a370481bc
(Accessed 15 July 2023)

51 Chandler, D., 2011. *Illuminance* by Rinko
Kawauchi, Aperture

52 https://www.bbc.co.uk/sounds/play/w3cswp2j
(Accessed 23 June 2023)

53 https://www.bbc.co.uk/sounds/play/w3cswp2j
(Accessed 23 June 2023)

54 https://autograph.org.uk/blog/artist-interviews/
long-read-interview-with-poulomi-basu/
(Accessed 23 June 2023)

55 https://www.palquest.org/sites/default/files/
Early_Local_Photography_in_Palestine_-_
The_Legacy_of_Karimeh_Abbud.pdf
(Accessed 14 March 2023)

56 https://www.palestine-studies.org/sites/default/
files/jq-articles/Karimeh%20Abbud.pdf
(Accessed 14 March 2023)

57 https://www.nationalgeographic.com/animals/
article/wild-explorers-ami-vitale-wildlife-
photographer#:~:text=Recently%2C%20
Vitale%20has%20focused%20on,black%20
rhinoceroses%20into%20the%20wild
(Accessed 19 May 2023)
Capturing the Connection Between Wildlife and
People' in *WILD* magazine (National Geographic)
October/November 2016 issue

58 https://www.amivitale.com/photo-story/
goodbye-sudan-the-worlds-last-male-
northern-white-rhino/ (Accessed 19 May 2023)
Vitale, A. 'Vanishing, The Last Goodbye', *National
Geographic* magazine, October 2019 issue

59 https://www.telegraph.co.uk/culture/
culturepicturegalleries/9854840/Lady-
Clementina-Hawarden-one-of-Britains-first-
female-photographers.html?frame=2473604
(Accessed 14 March 2023)

60 https://paper-journal.com/interview-dafna-
talmor-constructed-landscapes/ (Accessed
15 May 2023) Wilson, J C., 2019. *Paper Journal*.
Interview – Dafna Talmor

61 https://art.nelson-atkins.org/objects/48768/
martha-graham-american-document-trio
(Accessed 5 June 2023)

62 https://www.youtube.com/watch?v=Zg3lNY5Iq3o
*Visions and Images: American Photographers
on Photography*, 1981, Barbaralee Diamonstein-
Spielvogel Video Archive at the David M.
Rubenstein Rare Book and Manuscript Library,
Duke University (Accessed 5 June 2023)

63 https://artuk.org/learn/learning-resources/
maud-sulter-and-the-subversive-portrait
(Accessed 5 June 2023)

64 https://www.vam.ac.uk/articles/zabat-photo-
graphs-by-maud-sulter/ (Accessed 5 June 2023)

65 Sulter's 'Les Bijoux' series, 2002

66 http://image-matters-discourse.de/buch-ict/
interview-abril/?lang=en
(Accessed 30 June 2023)

67 https://www.youtube.com/watch?
v=oEgf1XmtWCo (Accessed 25 January 2023)

68 https://www.theguardian.com/artanddesign/
2016/aug/25/zanele-muholis-best-photograph-
out-and-proud-in-south-africa-lgbti
(Accessed 25 January 2023)

69 https://www.youtube.com/watch?
v=oEgf1XmtWCo (Accessed 25 January 2023)

70 https://www.youtube.com/watch?v=dNk098ffjLM
(Accessed 5 June 2023)

71 https://www.guggenheim.org/artwork/artist/
lorna-simpson (Accessed 5 June 2023)

72 https://www.theparisreview.org/blog/2017/11/
10/daring-woman-interview-lorna-simpson/
(Accessed 5 June 2023)

73 http://zofiarydet.com/zapis/en/pages/
sociological-record/discussions/rozmowy-
o-fotografii (Accessed 20 March 2023)

74 http://www.zofiarydet.com/en/pages/
research/interview/juliusz-garztecki
(Accessed 20 March 2023)

ACKNOWLEDGEMENTS

My deepest thanks to Laurence King for the opportunity to work on this incredible project. Thank you to everyone who has helped to make this book possible – Elen, Laura, Emily, Katie, Louise, Rob, Helen, Marc – to all the photographers, artists, gallerists, museums, agents and estates who have embraced the project, and to Tom, Aoife and Elowen – nothing is possible without you.

This book is for all women photographers, past, present and future, and every woman who works, has worked and has yet to work in photography. Thank you for everything you do, have done and will do; you are an endless source of inspiration.